PROFIT FIRST
—— FOR ——
PHOTOGRAPHERS

Develop the Habits to Transform Your
Photography Business from a Cash-Eating
Monster to a Money-Making Machine

Acknowledgements

Writing this book has been quite a journey filled with hard work, dedication, and the unwavering support of many wonderful people. I am deeply grateful to everyone who helped make this project a reality.

First, to my dear friend Rachel Siegel – your endless friendship and encouragement have been my anchor. Your gentle push and constant words of support got me started on this journey. Thank you for believing in me.

Thanks to AJ Harper for your invaluable insights, feedback, and education on the art of writing a book. Your wisdom and guidance have shaped the content and direction of this book in ways I couldn't have imagined.

To the amazing Em Agency team – your meticulous work and dedication have been crucial in refining this manuscript and ensuring its highest quality. Your expertise is truly appreciated.

I am deeply grateful to Felicia Reed and Jennifer Fink, who generously shared their stories and experiences. Your contributions have brought this book to life with real-world perspectives and enriched its content.

And to my wonderful husband, Dan Michael – your encouragement and understanding during the highs and lows of this journey have been immeasurable. You've stood by me through the long nights, moments of doubt, and bursts of inspiration. Your belief in me and this project has been a constant source of strength. I couldn't have done it without you.

Thank you all for being a part of this journey. This book is as much yours as it is mine

With love and gratitude,

Venus Michael

Copyright © 2024 Venus Michael

All Rights Reserved. This book or any portion thereof may not be reproduced or used in any manner whatsoever without the express written permission of the publisher except for the use of brief quotations in a book review.

ISBN 979-8-9908496-0-0 (paperback)
ISBN 979-8-9908496-1-7 (hardcover)

Printed in the United States of America
First Printing, 2024

P.O. Box 1426
Leander TX 78646
www.profitfirstforphotographers.com

DISCLAIMER: the information contained within this book is for informational purposes only. It should not be considered legal or financial advice. You should consult with an attorney or accounting professional to determine what may be the best for your individual situation.

Venus Michael and One21 Account-Ability do not make a guarantee or other promise as to any result that may be obtained from using the content. You should do your own due diligence and consult your professional team regarding questions specific to your situation. Venus Michael and One21 Account-Ability disclaim any and all liability in the even that any information, commentary, analysis, opinions, advice, and/or recommendations prove to be inaccurate, incomplete, unreliable, or result in any investment or other losses.

Contents

FOREWORD FROM MIKE MICHALOWICZ ... 2

INTRODUCTION .. 5

CHAPTER 1
Say No to the Side Hustle. ... 8

CHAPTER 2
Harnessing Your Habits .. 21

CHAPTER 3
The Bank Accounts .. 33

CHAPTER 4
Before and After: The Instant Assessment 41

CHAPTER 5
Your Profit First Roadmap .. 52

CHAPTER 6
The Big Picture: CEO Mindset ... 68

CHAPTER 7
Profit Your Way Out of Debt .. 79

CHAPTER 8
Reframe. Refocus. .. 90

ABOUT THE AUTHOR .. 100

APPENDICES .. 101

Foreword

FROM MIKE MICHALOWICZ

How come no one told me how stinking hard entrepreneurship is — *before* I started a business? As I look back, maybe someone did. And maybe, just maybe, I wasn't ready to listen. Now, I listen, to learn, all the time. I suspect you do too.

I've experienced three decades of entrepreneurship. During that time, I have faced struggles. Some so difficult that had I known they would happen, I likely would not have become an entrepreneur. But, alas, I did start a company, and then another, and more "anothers." Among the consistent stream of challenges I faced, there were some breathtaking (for me) successes. I suspect you have had some too. And, if you haven't yet, I am convinced you will by the completion of this book.

One of the breathtaking opportunities for me in 2022 was when I was invited to be the opening morning keynote for the Professional Photographer's Association (PPA). I spent the afternoon talking with many of the thousands of entrepreneurs who attended. Some had solopreneur practices. Others had multiple studios and dozens on their team. And I met folks who owned businesses of everything in between. I asked them about their biggest challenge, and the answer was almost always the same: profitability. It didn't matter how big the business was. It didn't matter how long the business existed. It didn't matter where they were located on the planet. The number one challenge was the same. These

businesses — photographers, videographers, makeup artists, photoshop experts, and other industry professionals — all wanted to learn — scratch that — master the path to permanent profitability. It's a universal struggle of entrepreneurs, me included. Better said, it was my struggle.

I built my businesses, in part, for financial freedom. I wanted to never worry about bills. I wanted to do what I wanted, in the way I wanted, when I wanted ... without concern for cost. And, thanks to Profit First, that's exactly how my business and life are today. I suspect you have a similar desire for yourself. If so, that's exactly what this book will do for you.

This is why I'm so excited about Venus Michael's new book, *Profit First for Photographers*. In your hands, you hold a transformative guide, where Venus shares practical strategies and actionable insights to help photographers overcome the hurdles of financial uncertainty and build thriving, profitable practices and studios. Through her own experiences and those of her clients, Venus understands the realities of running a photography business — the long hours, the creative challenges, and, of course, the financial pressures. She's been there, navigating the complexities of entrepreneurship with grit and determination, and she knows firsthand how daunting it can be to balance the demands of creativity and commerce.

I have been friends with Venus for a long time. I have watched her guide countless photographers to persistent profitability and have them experience residual benefits like confidence, patience, and comfort. As a result, Venus has become the Profit First and bookkeeping authority in the photography industry. It's not only because of what she teaches, but how. Where others see obstacles, Venus sees opportunities. Her approach is grounded in empathy and understanding, and she's dedicated to helping photographers like you navigate the complexities of business ownership with confidence and clarity.

In *Profit First for Photographers*, Venus offers a roadmap to financial stability and success, drawing on her expertise and insights to provide practical advice that's easy to implement. From budgeting and cash flow management to pricing strategies and revenue optimization, Venus covers

it all, equipping you with the tools you need to take control of your finances and build a profitable studio. Best of all, it is easy. No accounting degree needed. Shoot, you don't even have to like math.

As someone who understands the challenges of entrepreneurship all too well, I can attest to the importance of having Venus by your side. Her wisdom and guidance will empower you to overcome the challenges of running a photography business and achieve the success you deserve.

If you're tired of struggling to make ends meet and ready to take your photography business to the next level, I encourage you to dive into "Profit First for Photographers" right now. Financial freedom is just about 100 pages away.

Introduction

Do you remember when you were 6 years old playing "grown-ups" with your friends? Maybe you pretended to be a rock star, an astronaut, a doctor, or the president. At that age, you believed you could be and do whatever you wanted, and you would sit around and daydream about it. Then you grow up, graduate high school, and realize that you need to earn money just to survive. Your daydreams are out the window, and you get transported to a life where all you can do, day in and day out, is hustle. Hustle for food, rent, bills. Hustle for survival.

Then, all of a sudden, the craziest thing happens: Someone pays you for a photo you took. Your daydreaming starts again. *What can I do with this? Can I make a living doing what I love to do?* So, you give it a try only to find out you're just in another type of hustle — the side hustle, where money is going out faster than it's coming in.

Mike Michalowicz teaches us how our businesses have become a cash-eating monster and how Profit First can tame that monster and change it to a money-making machine. we're going to build on those foundational concepts and bring your profitability into focus.

You can do this, and, yes, you *do* deserve this! For you to get the most out of this book, I ask that you actively take in this information. There will be exercises that may make you feel uncomfortable or embarrassed, but please be honest with yourself while we take this journey together. This is a

judgment-free zone. Just thinking about what I am teaching you is not going to change your business or your life. It's not going to get you to profitability. Taking these needed action steps, while they may seem backward or may feel uncomfortable, if you take them, I can promise you will be profitable.

Just to be clear: This book is a derivative of the book *Profit First* by Mike Michalowicz. It's a great book that changed so many lives of business owners, including my own. If you have read his book, then I am so proud of you for already realizing you need to take your profitability seriously. If you haven't, don't panic! I am going to teach the system to you. I want you to imagine his book is the rock-solid foundation we're going to use to build your house of financial sustainability.

What's Coming

We're going to follow the journeys of Felicia and Jennifer — two different photography business owners with very different revenue amounts and photography styles. We'll also get help with the technical stuff from Poppy, a fictional character who is a combination of a few other photographers wrapped in one.

By using the power found in Profit First, these women have done tremendous things. Felicia now owns her studio space and is sought after by high-end clients. Her clientele will travel to her studio in Texas from all over the country, not just for a photoshoot, but for the Felicia Experience. Jennifer went from working all hours of the day and night for pennies to focusing on what made her happy and has made a name for herself in her niche. If you're near South Carolina and want those vast over-six-feet-wide collages of alums, sports teams, or employees, she is the one to seek out.

Profit First keeps you in constant communication with your money, so you're "in the know" about the financial health of your business. The better you understand your numbers, the better you'll be at making decisions about which direction to take, what vendors to use, and what price point you should choose. Anytime you think "Should I" or "Shouldn't I," you want to have all the facts, and this system will give you those answers.

By the end of this book, you'll know how to run a profitable studio that covers all your bills and ensures you always have a stash of cash. You'll know what things to consider and keep top of mind when it comes to running your business. You will also learn tips and tricks on how to rock the CEO position of your business.

You know when you hear about those business ideas and tools that sound like they could be the game changer to get you from where you are to where you want to be? Yet, you tell yourself things like, "I don't have time to implement this," or "I don't have time to learn, or "I have too much going on." You know that self-doubt you use to talk yourself out of something? Jennifer once had the same objections. After she started Profit First, she told me something very different. She said, "WOW! That's such a game changer. Why didn't I do this sooner?" Get ready for that to happen to you.

Reframe. Refocus.

As you read this book, I ask that you take some time and let the profitability come into true focus for you. Let everything else in the background blur. Give yourself permission to take this journey, to say "yes" to some new things, to get rid of some old bad habits, to stop worrying about taking care of everything else and focus on taking care of you and your business. I am going to lock arms with you and help you reinvigorate the thing you daydreamed about but thought was unattainable. Together, we're going to take your business from being a side hustle and set it up as a business that creates wealth for you and your family. Your daydream will become your reality. Are you ready?

CHAPTER 1
Say "No" to the Side Hustle

"This isn't working for me. I have got to stop doing all this work for no money." This thought was on repeat in Felicia's mind as she made the 40-mile drive home from a 10-hour photo shoot where she made only $75. It wasn't the first time she had this thought. But she was determined to make it the last.

Felicia's interest in photography started when her second child was born. She wanted to document everything her children were doing, to take better photos of her children, and to leave legacy photos for her family. While shopping for the family groceries, she saw a 35MM film camera and decided to purchase it. She spent a couple of years playing with the settings and attempting to capture the perfect photo, but she never mastered the 35MM camera. A few years later, for their 10th anniversary, Felicia and her husband, Alan, finally had the wedding they had never had. That's when she found Christopher, a local photographer, to come and photograph the wedding.

In conversation, Felicia mentioned her interest in photography, and Christopher offered to sell her his Canon digital camera. The first time she held the camera, she asked, "Where are the lenses?"

Christopher said, "There are no lenses. You need to use your kit lenses, and I'll teach you this exposure triangle thing."

Felicia had no idea what he was talking about, but she wanted to learn, so she took him up on the offer. They would meet in the park and just start taking pictures. She began to learn her way around a digital camera. She would spend hours practicing, always trying to figure out the best way to take the perfect photo of her own children..

Chapter 1: Say "No" to the Side Hustle

Finally, 10 years after her first camera purchase and countless hours upon hours of developing her photography skill, her friends and family started asking Felicia to take pictures of them. She would spend evenings and weekends on location — while still maintaining her full-time day job of sonography — spending hours shooting hundreds of photos for only $75. That was not her hourly rate; it was the price for the entire photo shoot, whether it took four hours or 10 hours of her time.

Felicia was at a breaking point. Her husband had not only started wondering about her spending, but was getting concerned with just how much she was spending. She struggled to manage her job and her business. And she didn't even want to find out if she was making a profit. How had this thing she loved to do — taking pictures of her family — turned into something that made her feel out of control?

Have you had your day of getting in the car and telling yourself, "I've got to stop doing all this work for no money"? Did you realize your pricing was out of whack, or your spending was out of control? Did you find that one thing you're passionate about but aren't sure how to make it work?

You're not alone. In my seven years of helping photographers manage their business finances, I've seen nearly every photographer reach this point. I like to think of it not as a breaking point, but a turning point — a point where everything starts to get better. A point where you reframe your thoughts and refocus your direction. You may be at this point right now. No matter how you got here, or the choices you made in the past, you too can turn a breaking point into a turning point.

Seeing Your Business Through a New Lens

A camera helps you see beauty in everyday things. You can take photos that capture emotions in the most mundane places and objects: landscapes, food, or even street signs. Photographs like this allow you to see the details and beauty through a lens and all the vibrant colors typically missed when just viewing it in the wild.

I have been overcome with emotion by seeing a photo of a bride's shoes. A pair of shoes, really?! There was nothing special about this particular pair; they were ordinary white high-heeled shoes sitting on a black marble table with a string of pearls loosely draped around them. To me, it symbolized purity, love, and commitment. Why did it bring me to tears? Honestly, I don't know. And neither did the photographer who took that photo, who was surprised when I told her about my reaction to it. She didn't even realize that her photos of simple objects could affect people. You see, one of her best skills was in the placement of props and the way she used the lighting. She had found her magic.

So, you took this skill, this craft, this hobby of yours, found your magic, and, *bonus*, got people to pay you for it. But how does that translate into money for you, for your back pocket? Wouldn't it be great if you could see your business through the lens? To pick up all the small details and vibrant colors of your business? To take that snapshot in time and study it? Guess what? There is a way, and that's what we're going to do.

5 Signs You're Stuck in a Side Hustle

All right, not to get all negative, but we need to talk about some business you may have stumbled into. These examples can clue you in knowing if you're still in Rite of Passage one.

#1: *You don't pay yourself.* Your clients are "paying" for your services, but are they really paying you? No. Instead, all they're doing is covering expenses — equipment, networking, advertising, printing. You get the picture. Maybe there are crumbs left over for you, maybe not. You, as a person,

are not paid for your time and talent. If you were working for someone else, this would be unacceptable. Why accept it from a business you own?

#2: You mix business and personal funds. This is a trademark side hustle move, and the accounting and legal ramifications that can arise from it are endless. At first, it can seem like the easier option. After all, the business is small, usually just you. But then you miscalculate your tax return, or someone sues your business, and now you've left the door open to all your personal assets. Not to mention, it's very unprofessional.

#3: You don't keep track of your paperwork. Are you a Susie Shoebox? Making the mistake of thinking that, since all your receipts are together in one place, you are an organized business owner? But then you find out when doing a tax return that you spent too much money on something or you don't have all the paperwork in that box. The whole point of the Profit First system is to keep your expenses in check.

#4: You don't think about taxes until tax time. Have you ever looked at your tax return and thought you might have a heart attack because what you owed was nowhere near the money you had? Maybe you've even had the IRS freeze your bank account or levy a paycheck. That's not a good feeling, if this ever happens to you, it can ruin everything you built.

#5 :You compare your business to others. Appearances are not always what they seem. It's a lot like a photo: the finished product looks fantastic, but that's only because you took the time to edit it. It looks like a better version of the person. This is typically what businesses will do as well. I tell you this because I want to stop you from comparing yourself to others. Instead, start comparing yourself to where you were in the past.

From Hobby to Hustle

The most successful photographers I have met in my career all started by picking up a camera and starting a hobby. Perhaps your story is similar. As your skill level improved, the photos you took were beginning to get noticed by friends and family. Not long after that, you were paid for a photo you took.

That might be when the light flashed for you, and you started to figure out that this can become a business.

Notice I didn't say a "profitable" business.

Here is where you might have hit a speed bump. Running a business is not all fun and games. Suddenly, you must figure out how to pay for expenses that come with business ownership, such as business insurance, corporation formations, advertising, maybe a team of people to help you, etc. You have money going out as fast as it is coming in. You may have been told that this is the norm. I am here to say that is not the norm, and let's fix that!

Through this book, I will teach you not only how to take your profit, but to make it a priority and take it first.

THE ENTREPRENEUR'S RITES OF PASSAGE

When you made the move from hobby (an activity you do for your own enjoyment) to side hustle (activity you do with the intent of making money), whether you realized it or not, you took the first rite of passage into entrepreneurship. A rite of passage is one type of turning point, a transition from one group to another. From here, your business can be in one of four stages:

STAGE 1
"I'm just doing this for extra money."
You're trying new things. You may be deciding if you want to photograph people or things, inside a studio or on location.

STAGE 2:
"I'm running a legitimate business."
This is when your business is financially supporting you, and can cover all your expenses without needing a second job.

STAGE 3:
"I'm creating jobs for people."
Now your business is financially supporting you as well as other people.

STAGE 4:
"I'm creating wealth for my family."
The family is also supported, and there may even be some generational wealth in this stage.

Like Felicia, you're stuck between stages one and two, between making a little money and running a legitimate business. You have spent a while focusing on your photography skills. Maybe you're even starting to become known for your style. You're building a name for yourself — or perhaps you already have built that name but can't get over the next hump. You're starting to see the money coming in, but you still don't see it coming home with you. Your pockets/wallet feel empty. Your lifestyle is not where you want it to be, and frustration is sinking in.

Have you ever felt moved by a testimonial from a client? Maybe they said you "changed how they see themselves" or "made them feel beautiful for the first time." You gave them something they were proud to show off to the world. Your work, your skill, your time, and your passion are important. I am here to help you on the journey of making sure your work is supported financially so that it can support you.

If you stay in the mindset of a side hustle, then side hustle money is all your business can give you. We are going to get you from stage one to stage two and set you up for success when you're ready for stage three. But in order to get there, you must first make that mindset shift for yourself.

Entrepreneurship has so many twists and turns. You can be riding high one day and plummeting the next. Sometimes it can seem like you're riding a rollercoaster. Other times it can seem like you're riding the biggest rollercoaster on earth, during an earthquake, while a hurricane is coming in.

Why do so many people do it? Entrepreneurs can find the biggest rewards and the most peace. Some of the rewards are being your own boss, making a living doing something you love, or creating a positive impact. It becomes a case of good versus bad. And for the people who make it in entrepreneurship, the good always outweighs the bad. And I'm not just speaking to you as a Profit First expert. I'm speaking from experience.

My Side Hustle Story

In 2004 I opened my own bookkeeping business after learning that not only did I enjoy accounting, but I was good at it. I registered with the state and IRS, joined the chamber, purchased business cards, and told my friends and family. This was amazing! I was going to be my own boss. Boy, was I wrong!

I quickly learned that just creating a business name and putting my number in the yellow pages wasn't going to make my phone ring. The first problem was that I am an introvert. It takes me longer to comfortably carry on a conversation with people I don't know. After months of only having one client that did not put any cash in my pocket (he was teaching my daughter jujitsu, and I was doing his bookkeeping), I resigned myself that my business was not a business, it was a side hustle.

Like so many of my clients once did, I looked for a full-time job that would pay my bills while I tried to make a go of bookkeeping. I ended up accepting a seasonal job with a national tax preparation franchise. When the season was over, I continued to look for employment. I had no luck at generating a phone call for an interview until one hot summer day, I was sitting on my couch watching *Days of our Lives* when my phone rang with a job opportunity with the tax preparation franchise I recently worked for. I agreed to come in. After all, I was sitting watching daytime TV.

When I arrived at the business, the owner offered me a permanent job that would be full-time during the tax season and three days a week in the off season. Since something is better than nothing, I accepted. As time went on, I got a little more responsibility that came with a tiny bump in pay. Within three years, I oversaw multiple office locations. I hired and fired and trained employees. I dealt with complaints. I cleaned the toilets. I did it all and I learned a lot about running a business, managing employees, and wowing customers. By that time, it wasn't about the money anymore, it was about my self-esteem. I felt appreciated, I felt needed, I had a purpose. I didn't want to go back to daytime TV.

I had been with the company for seven years when my boss upended my world; she decided to sell her business. When I asked her why, her reply chilled me to the bone. "We work this hard only to stress about making payroll. I am not making any money."

Chapter 1: Say "No" to the Side Hustle

I grieved for the loss of that job. It wasn't for the loss of the money because that wasn't much to begin with. It was for the loss of my purpose. I remember the morning after the sale was final, I woke up and cried. And then, I decided that I didn't want to find another job helping someone else build *their* business. I wanted to build my own. It was time for my side hustle to enter Rite of Passage two.

I went into hyperdrive, worked on getting over my introvert ways, and consumed all the free education I could get. I was searching for that secret sauce to make my business into something that could support me financially and make me feel proud of myself. I managed to get three paying clients. Even though the money was not enough, I was making traction. Six months later, I had grown to eight clients, and that's when I realized that the entrepreneur bug bite everyone talks about is real. I would lose a client and gain a client, but never really made progress to get the client list over 10 at any given time.

In 2015, my daughter was preparing to graduate high school, my husband wanted to retire after 35 years in his career, and I felt the pressure to make enough money to support the upcoming changes in my family. But I wasn't making money, not real money. By the time spring arrived, we were already a month behind in our mortgage payments and another one was due. I knew that this feeling of hopelessness was the prelude to rock bottom. Even with feeding my family cheap dinners and being very careful with every dollar we had, we were still at risk of losing our house. That's when I drove to the pawn shop with my wedding ring set, which was worth more than $7,000.

"I can give you $1,300 for them," the person at the pawn shop said. That was so not what I was expecting to hear.

The room started spinning. My heartbeat pounded in my head. I felt like my body temperature rose 20 degrees. In that moment, I could not control the aggressive shaking in my hands. Everything started going black, and I was afraid I might faint. My only thought was to get out of there — *don't let anyone see you like this, get to the car, go, Venus, GO!*

After what felt like hours (but was probably only minutes) sitting in my car where I could only scream, cry, and hit the steering wheel, I calmed myself down, collected my composure, and walked back into the pawn shop.

Although $1,300 was nowhere near what my rings were worth, it was more than I needed for the mortgage payment, so I pawned my wedding ring set.

By May, I had had enough. I went out to the back porch for a moment to enjoy the Texas blue sky. I was only there for a few minutes before the tears started falling. I felt like a failure. I'd done everything I was supposed to do, but seemed to get knocked down religiously just when I started to think everything was going well. I was in the trenches of despair, the lowest of lows. I can't think of another time in my life where I felt so depressed. I couldn't see a way out of my poverty. I couldn't see how I was ever going to have a comfortable life. Without even thinking about it, I said a prayer: "GOD, this can't be what you had in mind for me. I can't believe you would want me to suffer like this. Please help me."

Now I wish this was a story where I got my answer with booming thunder and a strike of lightning. It's not. I did get my answer, only at the time I wasn't aware it was my answer.

Before I tell you how he answered me, I need to tell you that my husband and I noticed a pattern in our life where the numbers 1 and 2 showed up multiple times a day in various forms. Over time I have learned to pay attention when I start to notice the 1s and 2s in places.

As I stood out there trying to stop the tears before my family could see me like that, I noticed a dragonfly. It flew only inches in front of my face, almost like it wanted me to notice it. We'd lived in that house for a few years, and I had never seen a dragonfly. Right behind it was another one, and then another. These dragonflies were making it a point for me to see them as they came around the east side of the house then turned the corner to go to the west side. I counted how many of them I saw. Can you guess? There were 21 dragonflies.

Now because I have learned to pay attention to those numbers, I googled to find out if dragonflies lived together like a herd or flock. According to the article I found that day, a dragonfly symbolizes that change is coming. I filed that information away and went about my day.

Two (there's that number again) hours later, my phone did that familiar ding: an email arrived. Without giving it a second thought, I picked up my phone to read the message. It was from someone I had never heard of before. To this day, I have no idea how I ended up on her mailing list, but I

Chapter 1: Say "No" to the Side Hustle 17

The dragonfly flew only inches in front of my face, almost like it wanted me to notice it.

am extremely thankful I did. A woman was announcing her new collection of podcasts that she had curated from leaders in the business arena. I could pay $297 and have access to all the podcasts at once, or I could log onto her website and have access to two of them for 24 hours, then the next day I would have access to two different ones until the cycle through all of them was over.

As you can imagine, I did not have the $297. So instead, I faithfully logged in every day and consumed the podcasts. This was a great collection, and three of them were life-changing for me. One of those podcasts featured Mike Michalowicz talking about his latest book and the process that changed his life and money situation for him and his family. To drive the final point, he ended the podcast with announcing his new additions to his destination backyard that the process in his book helped him create.

My house was a few years old, and the backyard was just dirt and fence. I had a vision of what I wanted it to be like back there but never had the funds to make my backyard dreams come true. Of course I logged onto Amazon and purchased the book.

That was the beginning of my Profit First story. By learning all I could and applying his system in my own life, and in my clients' businesses, remarkable changes started to happen. I made the shift from side hustle to legitimate business in six months. Now, I'm in stage three — I employ people to help me in my work. Knowing what my income and expenses are and how they relate to each other has given me a newfound superpower of looking forward to what's to come and starting my day. Being able to take the foundation of information that I have learned from Profit First and customize it to my needs and wants has afforded me the life of financial independence. I have not had to wonder where the money is going to come from for my bills, groceries, and life. My business finances are healthy, and I have been able to grow a team of dedicated people. I don't go to pawn shops. And I don't carry debt or worry about bills. And yes, I finally created my destination backyard that I enjoy with my dog.

We are living our dream of helping creatives, like you, eradicate entrepreneur poverty. I have helped many business owners come out of the trenches of despair and create their own financial success stories. Now I am writing this book to help you.

The Miracle You're Looking For

Jennifer Fink was 25 years old when she started her business and immediately purchased a retail space. Looking back, she admits, "It was probably ass-backwards, since a lot of photographers start off honing their trade, building their portfolio. I wanted to go straight into having work and home life separate."

She kept her living expenses low, just enough to cover rent, food, and necessities. A total of $800 a month. "So that's all I withdrew from the studio. But I never seemed to have money to reinvest into the business." Even though she didn't want a huge variety in her photos with the use of props and backdrops, not having a budget to invest in those things probably stunted her growth.

One of the fastest and most efficient ways that you can make the leap from side hustle to legitimate business (so you sleep better at night knowing that you have money in the bank) is to start setting aside the money you need to pay yourself, to invest in equipment and supplies for your business, and to reap the ultimate reward of entrepreneurship: profit. This is where Profit First, the cash management system created by Mike Michalowicz, comes in. When people hear "take your profit first," they assume it is just about profit, but it is really about making sure you have enough for your own pay, for taxes, and for investments in growth before you pay your bills.

Profit First isn't a replacement for a good bookkeeper or accountant. It isn't a system that will complicate your life. It isn't a fad. Profit First uses bank balance accounting and human behavior to help you manage your cash flow. It leverages the spending habits you already have while keeping the spending in check and allows you to ensure you have a paycheck *and* profit.

Now, I know what you're probably thinking: *"How can I take my profit first if I can't make ends meet?"* Do you ever go back and look at the photos you took when you started? You know, before you had any real skill at it? Notice the difference between those and the ones you take today?

When our children are babies, we don't judge them because they can't take more than a few steps or figure out how to get the food on the spoon in

their mouth instead of everywhere *except* their mouth. You know they are young and learning. Everyone starts somewhere.

That's why we are going to start right here and right now. You've taken the first step and opened this book. Together we are going to find the money for you to take home.

ACTION! Put your Profit in Focus.

What is your biggest goal for your business? More revenue? A studio space? Associate photographers? Streamlined processes? There is no limit. What is your most significant want? Where do you want your business to be in five years?

Send an email to *profit@venusmichael.com* with *"Profit in Focus"* in the subject line. Let me know where you're and where you want to be. I also recommend turning to the Profit First Commitment Card on page 108 and filling out the SMART Goal portion. (Don't worry about the Allocation Rhythm yet — that's next chapter.)

CHAPTER 2

Harnessing Your Habits

I remember the first time I saw my mother-in-law sitting at her table with a few envelopes and a huge stack of cash.
I sat down at the table with her, thinking she was working on bills, and quickly noticed that there were no bills on the table. When I asked her what she was doing, she said, "I went to the bank and pulled out the cash for my monthly spending."

"Don't you have a debit card?" I asked. "Why wouldn't you just leave it in the bank until you needed it?"

"Venus, this is something I've been doing all my life. My father taught me to manage my money this way. See, this envelope that's labeled 'groceries' is my grocery budget."

"What happens if you don't have enough in the envelope for groceries? Do you just go back to the bank?"

"No, that's how my budget tells me I'll be eating sandwiches."

At first, I couldn't believe that she was doing this. My mother-in-law wasn't poor; in fact, she was smart with money. Why would she eat sandwiches instead of preparing a more satisfying meal if she had money in the bank? It wasn't until about six years later when I was introduced to the Dave Ramsey Financial Peace University that I realized what she was doing was done by a lot of people everywhere.

You see, Mom was using a budget management system most people in her generation used, called the "envelope system." She had individual

envelopes for things like groceries, gas, clothing, fun, gifts, bills, etc. Every month, she made a trip to her bank and withdrew a predetermined amount to cover the things that were designated on the envelopes. When it was time to spend, she would go to her envelope; if the money was there, she was good to go. And if it wasn't, well, it wasn't.

Her generation knew exactly what it was like to live without, and this system was a great way to keep spending in check while still making sure her needs were met. And when she passed, she was able to leave a nice chunk of change for her children.

Profit First takes that same "envelope system" thought process and tweaks it for business. Instead of envelopes, we use bank accounts. Every account has a purpose, and a predetermined percentage. For example, If you want to buy a new backdrop but don't have enough funds in the equipment account to purchase it, that's your budget telling you that your current backdrop will have to do for now.

You must make the decision that you're going to be profitable. Grab it and do not let anything steer you away from that idea. You might need to take very small steps, but make the decision to be profitable and start with 1%. If you allow yourself to only take the leftover crumbs, then that's all there will ever be for you.

Success is to wake up each morning and consciously decide that today will be the best day of your life.

—Ken Poirot

Parkinson's Law: We create our own scarcity.

Let's say you've just bought a new camera, a model rated for 200,000 shutter actuations. You typically do four photoshoots a week, and you take around 350 photos per session. That means you're averaging 1,400 actuations a week. If you work 45 weeks out of the year, your annual shutter count is around 63,000. At this rate, that camera should last you three years.

So, during year one, you're taking taking a ton of photos with it. It's new, and you want to see everything it can do. You aren't worried about the "click count" yet. But, as you come closer to the three-year mark, you start to get more selective, because you want that camera to last as long as it possibly can. That's Parkinson's Law.

Named after Cyril Northcote Parkinson, Parkinson's Law states that "work expands so as to fill the time available for its completion." In other words, if you have a month to complete a given project, then according to Parkinson's Law, it will take the whole month to complete it. But if you only have a week to complete the same project, then you'll figure out how to complete it in a week.

It works for money, too. Imagine your favorite client tells you they want amazing photos to hang on their wall, and have budgeted $10,500. This is your dream project; you have so many ideas of how to pose the subjects and where you'll get the best background. Because you're a skilled professional, you know how to get exactly what the client wants for $10,500. But if the client had said the budget was $105,000, then you would have found a way to use the entire $105,000.

When you have an ample supply of a resource, you will use it all up without a second thought. However, as that supply shrinks, you're more careful when and how you use that resource. One of the key components of implementing Profit First is to create scarcity in the funds available to operate your business. Think back to when you were getting started and didn't have a lot of money. You still managed to get things done and grow your business, but as the money started to roll, you probably justified spending more and even told yourself it was a necessity. If we keep the resources that we have to operate our business tight, then we can still do the growing that we want to do without overspending. Parkinson's Law is a good way to think about this.

The Primacy Effect: We remember what comes first.

The Primacy Effect says that we as humans will have an easier time remembering and recalling information from the beginning of a list than the middle or end. I like the way Mike Michalowicz explains this in his book *Profit First*:

> *I am going to show you two sets of words. One set describes a sinner, and another describes a saint. The goal is, as quickly as possible, to determine which one is which. Got it? Good. Now look at the two sets of words below and determine which one describes the sinner and which one the saint.*
>
> *EVIL, HATE, ANGER, JOY, CARE, LOVE*
> *LOVE, CARE, JOY, ANGER, HATE, EVIL*
>
> *At first glance you likely identified the first set of words to be the sinner and the second set of words to be the saint. If you did, that is wonderful news, because it means you are a human being and are experiencing the Primacy Effect. In other words, you will thrive under Profit First.*
>
> *If you tried to figure out the catch as you were going through the exercise, that is awesome news, too; it means that you are an entrepreneur and are more than willing to break old systems (like reading left to right only), which also means you will thrive under Profit First.*
>
> *Now look at the set of words again. You will see that both sets of words are identical, just in the opposite sequence.*
>
> *So, when you see EVIL and HATE at the start of a set of words, your mind assigns greater weight to those words and less weight to the remaining words. When the set started with LOVE and CARE you put the weight there.*

Bank Balance Accounting: The path of least resistance.

Profit First takes advantage of a common business finance management habit called Bank Balance Accounting. Whether you know it by that name or

Chapter 2: Harnessing Your Habits **25**

not, you've probably been doing bank balance accounting since the day you opened your very first bank account:
1. Log into your bank.
2. See if you have money.
3. Make your decision.

You do it every time you want to know if you have enough money to pay a bill or purchase something. But technically, that's not what you're *supposed* to do. When faced with a decision concerning your money, you're supposed to do what I call the Six Steps of Doom — log into your bank; reconcile bank, credit, and loan statements; review your P&L; compare your P&L to your Cash Flow Statement; double check for accuracy between the two prior reports and the Balance Sheet (we're not done yet!); and run metrics on your Key Performance Indicators.

Whew! That's a lot to digest, and I'm pretty sure you aren't doing it every week like some business accountants say you need to. Implementing Profit First and using Bank Balance Accounting is a lot easier. Maybe we just leave the Six Steps of Doom to the accounting pros.

Flip the Formula

Part of the reason some of what you tried in the past isn't working for you is because you have been taught to think about your money from a Generally Accepted Accounting Principles (GAAP) frame of mind. GAAP is required for publicly traded companies, but the formula has also been adopted by most accounting professionals in the United States. In the 1930s, the GAAP formula was introduced with the intent of making sure all accounting professionals were working by the same set of rules, and when evaluating companies, investors could compare apples to apples. While GAAP itself is not bad, the main formula for establishing profit is a little outdated:

SALES − EXPENSES = **PROFIT**

Profit is treated as a leftover. Going back to Parkinson's Law, we know that we will use all the resources we have to get a job done. And thinking about

the Primacy Effect, we will focus on and remember what comes first. If your profit is the last thing on your list, and you're in the habit of using all your resources, then naturally you aren't going to have much "left over." We as entrepreneurs need to flip the formula:

SALES − **PROFIT** = EXPENSES

The math stays the same, but what is different is that we're taking our profit *before* handling our expenses. Let me show you the math.

GAAP: 500 (Sales) − 380 (Expenses) = 120 (Profit)
Profit First: 500 (Sales) − 120 (Profit) = 380 (Expenses)

See, we didn't change the numbers; we just made a conscious decision to flip the formula. If you don't have any profit, then this formula works even better to ensure you do have a profit. Even if that profit is just a dollar to start.

The Four Principles of Profit First

The story of how Mike Michalowicz came into the core principles is a good one. He was downright depressed after doing some dumb stuff with his business money, and was watching a program on PBS where a fitness expert explained why fad diets weren't sustainable. As he listened, Mike thought about what he was learning in the form of business dollars. Using these principles in thinking about your money Comparing weight loss to business finances may not seem easy to do, but it is a great way to think about developing healthy habits. Here is how it plays out.

PRINCIPLE #1: USE SMALL PLATES

The size of the dinner plate has increased over the years. If we have a bigger plate, we can put more food on it. If we put more food on it, we will probably eat more. If we eat more, then we consume more calories. And more calories equal possible weight gain. If you have less food on your plate, you will naturally consume fewer calories and still be satisfied.

The Principle for Profit: Instead of seeing your cash in one bank account as one lump sum, we're going to split it across multiple smaller accounts, each filled with the resources you have for that particular purpose. This helps you avoid consuming resources meant for something else.

PRINCIPLE #2: SERVE SEQUENTIALLY
I can't tell you how many times as a child I was told to eat my vegetables first. They were usually brussels sprouts, which to this day I do not like. But I know reason my family would tell me to eat my vegetables first was so I could get the nutrients I needed before I filled up on the emptier calories of bread or pasta.

The Principle for Profit: By taking your profit first, you're giving yourself the financial nutrients you need to thrive as a business owner before you empty your account to cover expenses.

PRINCIPLE #3: REMOVE TEMPTATION
When I'm at my local grocery store, I do my best to avoid the chocolate chip cookies from the store bakery. I know that if I walk by, I'll pick up a package, and if I pick up a package, I'll consume all of them in a matter of days. Weight loss professionals tell us not to even have those things in the house. Even if we think we have great will power, as humans we act on convenience. If we have the junk food in the house, then when we get hungry, it will be the easy, quick junk food we reach for. It's all about out-of-sight-out-of-mind.

The Principle for Profit: Not only do we use multiple bank accounts, but we also keep some of those accounts at a second bank. It's too easy to "borrow" from yourself in a time of stress. You'll have the best intentions of paying it back, but paying it back rarely happens. If you don't see your growing profit balance, then you won't be tempted to borrow from it. If it's at a separate bank, you will have to go through more steps to get to it.

PRINCIPLE #4: ENFORCE RHYTHM
When it comes to weight loss, don't wait until you're hungry (hangry) to eat. Instead, eat at smaller intervals. If you wait until you're hungry, you will likely overeat. But if you stay out of the highs and lows of hunger, you won't.

The Principle for Profit: Profit First has allocation rhythms, specific times of the month when you move funds between your various accounts. This can be a very powerful piece. When you set up a schedule, your business can talk to you in a language you understand. As you're get into your rhythm, you will become accustomed to the balance patterns in your income account. If it's off kilter, you can quickly research why.

The default allocation schedule is the 10th and the 25th of every month. But you can do it every Tuesday, every other week, on the 1st and the 15th, or, like me, on the 5th and the 20th. The important thing is that you set up a schedule. Typically, my clients will set up their schedules around when they pay their bills or when they run a payroll. You may find that's easy because you already have money on the brain.

Ideally, you can think of it this way. If you log into your income account and are accustomed to a certain balance but it is higher, that is also the studio talking to you. Maybe you immediately know why. You made that big sale, or more sales, for example.. Maybe you are not sure what made it spike up, but then you can look back and see what you did in the last few weeks and keep doing it. During this process, your studio will tell you one of three things:

1. You are doing something good and making more money, so keep doing it.
2. Houston, we have a problem. Time to do some research and seek help.
3. All is well, it is business as usual.

Comparing weight loss to business finances is a great way to think about developing healthy habits.

CLIENT VIGNETTE
The Power of the Allocation Rhythm

One day, I logged into my client Jason's bank accounts all set to move his money. I had been doing his allocation for a number of years — every month on the 10th and 25th like clockwork — and was accustomed to a particular starting balance in his income account. Upon logging in, I immediately noticed the balance was about half of what I was expecting. This can happen for many reasons, but it was not the norm for my client. I looked at the transactions, and his most recent deposit was the prior day. So, to verify, I called him.

"Jason, I'm getting ready to do your allocations and noticed the balance in your income account is different. Did you take a week off?"

"No."

"Maybe there's some money out there that clients haven't paid yet?"

"No, it has been business as usual here."

"Well, something is off. Your balance is about half of what it usually is."

"Let me research and get back to you."

A few hours later, Jason called and let me know that his merchant had disconnected, or stopped depositing into his bank account. It had started again, which is why I saw the deposit on the prior day. His money was lost in cyberspace for a few days. Had Jason waited until he reviewed his bookkeeping financial report, the money could have been lost in cyberspace for weeks or even months. By being accustomed to the allocation amounts, we found the problem in less than two weeks. As you can imagine, the next allocation I did was much bigger than usual.

In all the years of my career, this is the only time I have seen this type of issue with a merchant account. I share this with you not to scare you, but to show you the power of setting up a rhythm and knowing how much money you are expecting in your income account.

The Habit Loop

According to Merriam Webster, a habit is "an acquired mode of behavior that has become nearly or completely involuntary." You see, our brains go toward what appears to be safe or comfortable, and away from what appears to be unsafe or uncomfortable. In the caveman days, humans would go toward food and away from predators. Our brains associate safety with things that are familiar, things we've done before. As time goes on, we gravitate to the same thoughts and actions, conditioning our brains to create habits.

In the book *A Power of Habit* by Charles Duhigg, he explains a simple neurological loop that is the center of every habit. The habit loop has three parts, a cue, a routine, and a reward. The cue, which I renamed "trigger," will do that just that—trigger the habit. It can be an emotional state, time of day, or, for our example, a bank deposit. The routine, which I have renamed "behavior," is how you react to the trigger. And the reward, which I have renamed "result," is what becomes of your behavior. Every habit, no matter what it is, has these three parts. Whenever you want to change a habit, you need to identify which part is which.

Right now, what is happening in your current habit is: Money is being deposited into your account, you're spending the money without assigning any purpose to it, and then you're left with crumbs when everything is over. You have nothing to show for your hard work.

CURRENT HABIT LOOP

- **Trigger**: Money deposited into bank account.
- **Behavior**: Spend money without intention.
- **Result**: No money left to show for your hard work.

FUTURE HABIT LOOP

- **Trigger**: Money deposited into bank account.
- **Behavior**: Move money to different accounts via Profit First.
- **Result**: Financially healthy business and personal life.

We want to rewire your brain and change this habit to: Money is deposited into your account, you assign a purpose and only spend per that predetermined purpose, and you're left with profit when everything is over. You have a stash of cash in your bank.

We must change your behavior, and Profit First is the perfect tool for that. The first couple of times, it will feel clunky, and you must be very intentional in the behavior. In 2009, by Dr.Phillippa Lally conducted a study that found it takes an average of 66 days — or three months — to build a habit. By the time the third month rolls around, the habit has already started to form, and the clunky feeling is no longer there. This is when you might start thinking that you can't imagine doing it any other way.

BREAKING THE LOOP: NEUROPLASTICITY

Until very recently, scientists believed that when we enter adulthood, the neural pathways we developed as children become permanently wired, and the brain is no longer capable of creating new ones. However, research now shows that our brains *do* continue to change and adapt in response to our experiences. This is called neuroplasticity (*nr-ro-pla-STI-si-tee*), basically the human brain's ability to "rewire" itself. There's actual science behind telling you that we're going to change the way you think about your money and create new habits.

The brain's neural pathways are often illustrated as a map of a city with millions of roads lighting up every time we feel emotions or think of doing something. The well-traveled roads or the larger roads are our habits and established ways of thinking. When we try to change a habit or way of thinking we start to carve out a new road. The more a road is traveled, the larger it becomes. The larger the road becomes, the more it ingrains itself as a new habit. The old roads get used less and weaken. All your life experiences, all the people you have interacted with and the places you've been have affected who you are and how you think.

One example of this from my life I remember like it was yesterday: My teacher, Mrs. Ross, was standing in the front of the classroom, wearing a blue sweater. She would name a state and then call on someone to name the capital. I held my breath every time. I was so scared she would call on

me for a state with a capital I did not know. YES, that's what happened, not once, but twice. The whole class laughed, and I cried with embarrassment.

After school that day I went home with my friend Lisa. As we walked in the door, Lisa's mother noticed I was not happy and asked me what was wrong. I talked about my day and what it felt like to answer wrong both times I was called on. That's when Lisa's mom pulled some index cards out of the drawer and wrote the names of all the states on one side and the capital on the opposite side. She had just made me my own set of flash cards.

Lisa and I made a game out of them. She would show me a card with a state name on it and I would try to answer with the capital name. Then I would show her a card with a state name on it and she would answer with the capital name. We would each be awarded two points for every one we got correct, with 1 point taken away from our score for each incorrect answer. Through play and repetition, my brain was able to build new "roads." The following week, the class was quizzed on the lesson, and I passed with a 94%.

I want you to create a new habit of practicing Profit First. Because this is not yet familiar to your brain, you need to be intentional about it. Thinking about neuroplasticity, we need to intentionally carve new roads in our brain until those roads are so well traveled they become completely involuntary, and you follow them without really thinking about it.

ACTION! Open your Profit account.

Let's take your first baby step. Go to your bank and open one account — nothing fancy — and nickname it "Profit." Starting tomorrow, you're going to transfer 1% (that's a penny for every dollar) of every new deposit to this account. For now, we're just going to let those pennies accumulate. And just like that, you've started taking your Profit First.

I also recommend returning to your Commitment Card (page 108) and filling out that Allocation Rhythm portion we skipped last time.

See page 101 for more information on opening a business bank account.

CHAPTER 3

The Bank Accounts

I'm not going to lie — when I started Profit First, I was hesitant to try opening five bank accounts at once. *"They're going to think I'm doing something wrong or illegal,"* was the only thought that went through my head as I walked into my local credit union. But the teller didn't flinch, judge, or say "let me go get a manager" like I was expecting. They didn't even react. I walked out of the building with a huge weight lifted off my shoulders. I had taken the first step toward changing my profit trajectory.

Just opening the accounts didn't instantly make me profitable, but it felt good. I could see the light at the end of the tunnel. When the calendar finally turned to July 1, 2016, I took my very first profit distribution of $136 and I was hooked. To this day, that $136 is in an envelope in my safe with a note on it that says, "Life is getting better." I keep it there to remind me of where I was and where I'm going.

Jennifer, who we met in Chapter 1, delayed implementing Profit First in her business for similar reasons. Before Profit First, Jennifer was in that cycle of insanity. She knew she needed to get out of it but wasn't sure how to do it. She worried that adding multiple accounts would only make things more complicated, but it did the exact opposite. Jennifer now had money to invest back into the business. That led to more sales, which resulted in more revenue. It became the miracle she was looking for.

Jennifer has said, "How do you introduce a new product line into your business without the funds to market it and have samples of it? You can

wish all you want, but just wishing for it is not going to make anything happen if you don't have the funds to back it up." Without the funds set aside for this new product line or offering, you might have to stop other offers to focus on the new potential revenue stream. Or you may end up working all hours of the day trying to do both, because at the end of the day, you still need to pay the bills.

Now let's get the tools you need to create a panoramic view of your business finances. Before you go any further, let me reassure you that this might sound difficult, but what I'm about to ask you to do will make it super simple.

Setting Up the Bank Accounts

The original Profit First suggests opening five separate bank accounts. This book includes three additional accounts I recommend especially for photographers. Together, these eight accounts will give you a snapshot of your business's financial health. Because you will be moving money into and out of them frequently, most of these accounts will be checking accounts. The Profit and Tax accounts are better as savings accounts, since they will only be withdrawn from quarterly.

Income. All payments you receive, whether it's cash, check, or credit card, will be deposited in this bank account. Your money will accumulate here until it's time to move your money to your other bank accounts.

Operating Expenses. Also referred to as "OpEx," this is the account that will pay your bills. Many people simply rename their existing business checking account, since they already have a debit card, checks, and autopay running through it.

Owner's Pay. We have an account for the purpose of paying you a salary. This needs to be a business account. Do not use this account for personal spending. Eventually you're going to build a buffer in it that will cover six months of your salary.

Tax. This is a holding account for that money that belongs to the government. When the time comes to pay the tax bill, you'll have enough to cover the tax liability for both the business and the owner.

Profit. This is a holding account for profit, your reward for being financially responsible. Some people I've worked with call this the "fun-me account." This is where you take your profit distribution from when the time comes. What you do with that money is all about you. Some will fund big personal purchases; some will contribute to personal savings. I remember a few years ago I had seven clients who used their profit distributions to fund a trip to Florida to stay at Disney, while nine clients used their profit distributions to fund a trip to California and stay at, you guessed it, Disney.

Growth. Transferring a small percentage into this account and letting it build up will help with those expenses that come from growing your business. It includes continuing education, masterminds, and conventions or conferences.

Equipment. Lights, Camera, Lens, Computer! You don't buy them often, but when you do, it can feel like a punch to the gut, with a typical price tag starting at $2,500. This account is for all the expenses for equipment you need to do your job.

Sales Tax. In most states your services are at least in some part taxable. That means you should be charging the appropriate sales tax and paying the state department at the appropriate intervals. This account is for holding the money that isn't yours to begin with.

Bonus Accounts. I consider these eight accounts to be the main essentials, but many of my clients choose to open additional accounts to help them budget for more specific purchases. (A list of the more popular account types can be found on page 103.)

REMOVE TEMPTATION: SECONDARY BANK

You wouldn't reward yourself for losing weight by going on a cruise with a 24-hour all-you-can-eat buffet. But the idea sure is tempting, isn't it? Likewise, if you do not remove temptation, it becomes too easy to "borrow" from yourself when times are tight or when that once-in-a-lifetime deal

Download a PDF of the eight Profit First bank accounts at profitfirstforphotographers.com.
For more information on opening a business account, see page 101.

comes around. If you borrow from your accounts that are set aside for these purposes, you're undoing everything you worked so hard to achieve.

We need to get your Profit and Tax money out of sight and out of mind to prevent the temptation you might have to borrow from yourself. We do this by setting duplicate accounts at a secondary bank. For those accounts, you don't want any fancy options. Ideally you can make it a savings account that will pay you interest, so you can have your money earning you money.

Here is what your money movement is going to look like:

```
                    MAIN
                    BANK

                   INCOME

    PROFIT        EQUIPMENT        TAX

SALES      OWNER         BUSINESS      OPERATING
 TAX        PAY          GROWTH         EXPENSES

                  SECONDARY
                    BANK

    PROFIT                            TAX
```

Let me answer the questions I know you have right now:

"Why are the Profit and Tax at two different banks?" The day you move your money, you're going to move it to your main bank. When you then move it to your secondary bank. That process typically takes a few days. You want to get it out of your income account and set it aside for the purpose it has. The Profit and Tax account at your main bank is just a holding account.

"Why can't I just let my money stay in the Income account until it moves to the secondary bank?" The most powerful thing that bank balance accounting will do for you is quickly show you the balances in each individual account. Remember, each account has a purpose, so you will want to see it dividing up that way before you send it off to your remove-temptation accounts.

Poppy's Bank Accounts

Poppy was excited and eager to start on her very own profit journey, but the first step of opening another account got her thinking. She wasn't unhappy with the bank she was currently using, but she also wasn't happy with it. She had the same checking account she'd opened when she was in high school. On her daily commute, Poppy drove past at least a dozen banks and never really understood what made them different. To her, banks weren't much more than a place to cash checks and get a debit card.

She started asking friends and family where they bank and why. Their answers ranged from practical answers like convenience and location, to answers like "it's where my parents bank." She hit the internet to read reviews, compare features and fees — and ended up more confused than before. Out of frustration, she opened her Profit First accounts at her current bank even though deep down she knew it was probably not the best option.

You see, Poppy had a case of analysis paralysis, that all-too-relatable experience of over-analyzing a situation to the point that you can't move forward. Not only can this cause stress and anxiety and become mentally demanding and lower your performance in everyday tasks, but it can also stunt your creativity. Hello, creativity is your money maker, we cannot have you implement a system that stunts your money maker.

That's why I sat down with my good friend Melissa Darveau, a business banker with 23 years of experience, help get Poppy out of analysis paralysis.

KNOW WHAT YOU NEED
Let's start with online banking. When you first start your business account, you might need to use online banking to just check your balances, transfer money back and forth, and be able to report your debit card is lost or stolen, things like that. But when you have a lot of complexity, you might want to do wire transfers online, or you might want to do ACH (Automated Clearinghouse Network, which is basically electronic funds transfer) services online, or you might need extra users to be able to view your account so you don't have to take time out of your day to do that as a business owner.

One of the most popular online services is the ability to send and receive ACH payments and wire transfers. But those can come with fees, so pay attention to the small print. Most banks, if they're charging you every month for your account, may not have fees because they're already getting their money from a monthly maintenance fee. The banks that aren't charging you a monthly maintenance fee will probably charge you for that service. There's no such thing as free banking. It's like the basic economic lesson that they taught in school, there's no such thing as a free lunch. Meaning, somewhere there's a cost involved and it must get covered just like in any business.

BANK LIKE A BUSINESS
A lot of people who have a side hustle will think, "I'm not big enough to have that checking account, so I'm going to just have a second personal account." What that does is create a nightmare scenario for your accountant. You'll end up spending more money down the road because you have it all melded together. You won't remember an expense that was personal versus business a year later when you're trying to reconcile.

The minute you start earning income on that side hustle, even if it's not full time, it's a business, and you need to have a business checking account, period. Most institutions are going to have some type of debit card usage requirement, or they're going to have a minimum balance or average balance

requirement to maintain. If you have a side hustle, you may have thought, "I can't do those things, I can't meet those requirements, therefore I might have to pay a fee." Sometimes that is the right move if that bank provides the right services that you need online or you really like their brick-and-mortar stores, or there's some reason you think the cost is justified. There's something that they're going to charge you for, whether it's for having extra services online, receiving copies of checks, or doing a wire transfer.

> *"Great things are done by a series of small things brought together."*
>
> —Vincent Van Gogh

DON'T BREAK THE BANK
Find an institution that has the best cost structure for your needs. If you can, find a bank that offers free business checking accounts. The typical drawback to the "free account" is transaction limitations—a certain number of deposits/withdrawals permitted before you start to get charged for them. The fee is usually 25 to 50 cents per transaction. So, depending on how many transactions you have, you might outgrow that account quickly. Usually when you're outgrowing it, you're going to nicely fit into the next account level.

The other thing to consider is that a lot of banks will waive fees on at least one if not two accounts, if you use their merchant services processing system or if you get a business credit card.

The decision to open a business savings account or money market account just kind of depends on how much cash you have. But those are great products. Now, you're not going to get a free business savings account without having to jump through a hoop. Most banks are going to require an automatic transfer every month. This is a scheduled transfer from a

checking account to a savings account, or from a business checking account to a business savings account — not something you do on your own.

POPPY'S ACCOUNTS

Poppy found a bank that fit exactly what she was looking for. From there, it didn't take long to get her accounts open. Then, she logged into her banking portal and renamed each account after the Profit First system. She also adds the last four digits of the account number in parentheses, which will make it easy to match each account with the monthly bank statements.

Now Poppy has peace of mind knowing she has her accounts at a bank that's right for her. Her money-making creativity is sparking again!

MAIN BANK

Income (5874)
Profit (5628)
Tax (5798)
Owner's Pay (5843)
Business Growth (5739)
Equipment (5438)
Operating (5672)

SECONDARY BANK

Profit (4395)
Tax (4261)

ACTION! Set yourself up for success.

Download the cheat sheet from profitfirstforphotographers.com to document your bank accounts. This will be helpful for your bookkeeper to understand what you're doing and why, but it will also remind you why you started this process, help track your progress, and plan for the future.

CHAPTER 4

Before and After: The Instant Assessment

Profit First describes your money not in dollar signs, but in percentage signs. Everyone's financial situation is different, so $100 can be a lot of money or nothing at all, depending on how much you have.

Enter the Instant Assessment. This is where we finally get the first snapshot of what your Profit First journey will look like. It starts with figuring out our *Current Allocation Percentages (CAPs)*, which is how you currently divide up your revenue, and *Target Allocation Percentages (TAPs)*, which is your goal for how you'd like to divide up your revenue. Think of it like this: your CAPs represent your "before" photo, and your TAPs represent your "after" photo.

I sometimes refer to this as the "ice bucket moment," because, fair warning, filling out the Instant Assessment may feel like getting a bucket of ice water dumped on your head — shocking, and maybe a little bit sobering.

Before we get started, I want you to know that your Instant Assessment is not a reflection of your ability to manage finances or run a business. They are just a starting point, likely the same starting point as the vast majority of photographers (and business owners in general) who aren't taking their Profit First. It's normal. You are normal. And one day very soon, you will look back at this "before" photo and feel nothing but pride for how much you've grown.

First, we will need to have your current numbers on hand. Take a moment to gather (or have your bookkeeper gather) this information from the last 12 months:

1. Profit and Loss statement (P&L) or total of sales and expenses. Maybe you track your sales on an Excel spreadsheet. If so, it's easy to get the information you need to fill out the Instant Assessment. Simply auto sum your column. If you're using a CRM, see if it has a bookkeeping section where you can print a sales report. With accounting software, you can easily print your P&L. Maybe you don't track your sales in anything like this. If that's the case, you want to start!

2. Bank and Credit Card statements. If you have a P&L, then this will be quick. Use a highlighter to mark anything that left your business accounts for a *personal* reason and total that number. If you don't have a P&L, color-code your expenses with three different colors of highlighter — one for personal expenses, one for Cost of Goods expenses (explained below), and one for regular business expenses. Every debit/withdrawal should be highlighted. Total the numbers for each color.

Stay with me. I've been told by many creatives that listening to this part is like hearing the Charlie Brown teacher voice "wah wah wah wah." Let's take it slow, one step at a time.

> "We think, mistakenly, that success is the result of the amount of time we put in at work, instead of the quality of the time we put in."
>
> —Arianna Huffington

Chapter 4: Before and After: The Instant Assessment **43**

Your Before Photo

Now that you've gathered your numbers, let's follow along with Poppy as we fill out our Instant Assessment. She is using a blank Instant Assessment worksheet which you can find in the Appendix (page 109) and on profitfirstforphotographers.com.

Poppy's Instant Assessment

	CURRENT $	CAPS	TAPS	PF $	THE BLEED	THE FIX
REAL REV.						
OWN. PAY						
TAX						
GROWTH						
EQUIP.						
OpEx						
PROFIT						

Download a printable PDF (or a fill-in-the-blank Excel file) of this assessment at profitfirstforphotographers.com.

CALCULATING YOUR REAL REVENUE

Let's take a look at the list in the far left column. Your Real Revenue is the net amount your business earned (Top Line Revenue), minus the amount you spent in order to earn that revenue (Cost of Goods Sold). We'll start by getting these two numbers.

Top Line Revenue includes session fees, digital and print art, and packages. Looking at the number that was deposited in your bank account will not work for this exercise. The deposit amount generally does not match the sale amount because that could include sales tax or payment processing fees information. If you were able to pull a P&L, this information is on the top of that report. If you weren't able to pull a P&L, you can also find this

information by logging into your electronic payment processor such as Stripe, Square, or PayPal.

Poppy's Top Line Revenue. According to her Stripe account, Poppy earned $498,514 in the last 12 months.

Cost of Goods Sold (COGS) is easy to confuse with other types of expenses. The difference is, COGS only includes the costs incurred as part of the process of providing your service. The common ones for photographers are hair and makeup artists; editing (labs); rental of a venue, props, wardrobe; shipping; folio boxes; printing; and associate photographers. Your accounting should classify them as Cost of Goods Sold or maybe Cost of Sale. If you aren't using an accounting software, looking up expenses by vendor name will work.

Poppy's COGS. Her expense report shows a total of $194,420, including:
- Labs and Printing: $96,420
- Wardrobe Rentals: $7,197
- Professional Specialized Editing: $34,698
- Hair and Makeup: $22,500
- Associate Photographers: $33,605

Real Revenue. With Top Line Revenue and COGS in hand, we can finally see how much your studio *actually* made in revenue. This is the number you will write in the first column.

Poppy's Real Revenue. $498,514 minus $194,420 leaves her with $304,094.

	CURRENT $
REAL REV.	$304,094

OWNER'S PAY

When I talk with photographers about this part, I hear a lot of "I don't pay myself." While that's not OK, it's also not entirely true. Do not confuse this line with thinking only about the money you take out of the studio bank account and stick in your personal stash.

For this exercise, we start with the funds that were moved from the studio account to your personal account. Then we need to go over everything that was spent from the studio account that was for your benefit.

Chapter 4: Before and After: The Instant Assessment 45

For example, if you swiped the business debit card to buy groceries or that new pair of jeans that have that "just right" fit on you. If the studio spent any dollar for your personal gain, that number is going to go here. We also need to include the salary and gross wages the studio pays you if you're on an official payroll system. In this instance, we don't just want the net (take home pay), but we need the gross (total wages) before any deductions.

Poppy's Owner Pay. Poppy looks at her bank records to find out that she transferred a total of $83,650 from her business checking to her personal checking. She also used the business debit card for $1,985 of personal expenses. Adding those numbers together, the business paid her $85,635.

	CURRENT $
REAL REV.	$304,094
OWN. PAY	$85,635

TAX

This is the amount the studio paid for income tax on behalf of you or the business. Maybe the studio reimbursed you for the tax that you paid yourself. That would also go here. Remember this is not how much money you paid in taxes, but how much the studio paid *for* you. (Don't be shocked if this number is 0. It usually is when just starting with this system. We're going to fix that!)

What about sales tax? Some will try to add this along with their income tax. That is not counted here, nor is it included in the revenue, nor is it an expense. Sales tax was never your money, so we do not include it in the Instant Assessment.

Poppy's Tax. Poppy notices that there are zero payments for taxes from the business checking account.

	CURRENT $
REAL REV.	$304,094
OWN. PAY	$85,635
TAX	$0

BUSINESS GROWTH

Look for all those dollars spent on activities to grow your business. Did you go to Imaging USA or another photography convention? Are you part of a

networking group like BNI (Business Networking International)? Did you join a mastermind online or in person? Did you hire a coach? Don't forget the continuing education classes.

Poppy's Business Growth. This past year, Poppy went to a conference, joined a mastermind, and took a couple of online classes. All the money spent for those activities totals $28,188.

	CURRENT $
REAL REV.	$304,094
OWN. PAY	$85,635
TAX	$0
GROWTH	$28,188

EQUIPMENT

This is actual equipment, typically electronic, that you bought to do your job, such as lenses, spare disk drives, and monitors. These purchases are the ones I mentioned earlier and how the price tag can feel like a punch to your gut.

Poppy's Equipment. Poppy had to purchase a computer, new lights, and a new camera this year. That set her back $15,283.

	CURRENT $
REAL REV.	$304,094
OWN. PAY	$85,635
TAX	$0
GROWTH	$28,188
EQUIP.	$15,283

OPERATING EXPENSES (OpEx)

Everything else you spent! Otherwise known as overhead expenses. If your studio spent the money and it's not already counted in one of the other categories, it goes here.

Poppy's OpEx. All her remaining expenses total to $174,846.

	CURRENT $
REAL REV.	$304,094
OWN. PAY	$85,635
TAX	$0
GROWTH	$28,188
EQUIP.	$15,283
OpEx	$174,846

PROFIT

This is the only time you'll see us take profit last. Total up your Owner's Pay, Tax, Business Growth, Equipment, and OpEx and subtract that number from your real revenue. This is the amount of money your business has earned for you. Here comes the ice bucket.

Poppy's Profit. Altogether, Poppy's expenses total to $303,952. She subtracts that from her Real Revenue, and is left with $142.

	CURRENT $
REAL REV.	$304,094
OWN. PAY	$85,635
TAX	$0
GROWTH	$28,188
EQUIP.	$15,283
OpEx	$174,846
PROFIT	$142

Whew, that's one column done. Now we can move on to the "CAPs" Column. Don't stress, I'll be right here to walk you through it.

THE CAPs COLUMN

Let's figure out our Current Allocation Percentages (CAPs). Pull out the calculator because we're going to do some math. If this section is causing you to hyperventilate, remember that this image will be incredibly important and helpful to capture. You cannot have an "after" photo without a "before" photo.

To calculate CAPs for each expense category, divide the Current $ value by your Real Revenue and multiply by 100. Round to the closest whole number and tack a % sign on the end. Here are Poppy's numbers:.

- Owner's Pay: 85,635 ÷ 304,094 x 100 = 28%
- Tax: 0 ÷ 304,094 x 100 = 0%
- Business Growth: 28,188 ÷ 304,094 x 100 = 9%
- Equipment: 15,283 ÷ 304,094 x 100 = 5%
- OpEx: 174,846 ÷ 304,094 x 100 = 58%
- Profit: 142 ÷ 304,094 x 100 = 0.04% (Round down to 0%)

We end up with something that looks like this.

Poppy was shocked to realize her six-figure business earns absolutely no profit, and just 28% of all the money she made went home with her.

The first time I did this exercise for my business, I had my own ice bucket moment. No profit. Not even a dollar. Even though I have a background in accounting, I was doing

	CURRENT $	CAPs
REAL REV.	$304,094	
OWN. PAY	$85,635	28%
TAX	$0	0%
GROWTH	$28,188	9%
EQUIP.	$15,283	5%
OpEx	$174,846	58%
PROFIT	$142	0%

something wrong. In fact, I was doing it really wrong. It was that day that I vowed to never have another zero-profit year.

Your After Photo

Target Allocation Percentages (TAPs) are your aspirational goal, where you need your photography business finances to be. Below is a chart of healthy company TAPs that Mike Michalowicz put together based on his research of countless companies.

	$0-250K	$250-500K	$500K-$1M	$1M-5M	$5M-10M
OWN. PAY	48%	35%	20%	10%	5%
TAX	15%	15%	15%	15%	15%
GROWTH	2%	2%	3%	3%	3%
EQUIP.	3%	3%	4%	4%	4%
OpEx	27%	35%	43%	58%	58%
PROFIT	5%	10%	15%	10%	15%

Chapter 4: Before and After: The Instant Assessment **49**

Please keep in mind that percentages are not the be-all and end-all for everything and can be adjusted to fit your business's needs and goals. Here is what I've found to be true for the creative industry: With every jump in revenue brackets comes a new set of expenses. When you're just starting out and doing less than $250K in real revenue, you are the key employee and there aren't too many expenses to cover. When you jump up a bracket — maybe you hired an employee or invested in some software to track your projects — your Owner's Pay goes down but the Profit goes up, and so does the money in your pocket. As you continue to grow, the business will need more people, more software, more equipment. At this stage, you're also thinking about creating the reserves for slower months.

Looking at the chart, Poppy sees that, based on her real revenue amount, she falls under the B Column. She copies those percentages to the TAPs column.

	CURRENT $	CAPs	TAPs
REAL REV.	$304,094		
OWN. PAY	$85,635	28%	35%
TAX	$0	0%	15%
GROWTH	$28,188	9%	2%
EQUIP.	$15,283	5%	3%
OpEx	$174,846	58%	35%
PROFIT	$142	0%	10%

Still with me? Good! Now let's get to the good part: multiply your Real Revenue by the TAPs percentages (as decimals). Write that number in the Profit First (PF) $ column to see what your numbers would look like if you were already implementing Profit First into your business.

PROFIT FIRST FOR PHOTOGRAPHERS

This is Poppy's first glimpse of her "after" photo.
- Owner's Pay: 304,094 x 0.35 = 106,424
- Tax: 304,094 x 0.15 = 45,614
- Business Growth: 304,094 x 0.02 = 6,082
- Equipment: 304,094 x 0.03 = 9,123
- Operating: 304,094 x 0.35 = 106,424
- Profit: 304,094 x 0.10 = 30,409

	CURRENT $	CAPs	TAPs	PF $
REAL REV.	$304,094			
OWN. PAY	$85,635	28%	35%	$106,424
TAX	$0	0%	15%	$45,614
GROWTH	$28,188	9%	2%	$6,082
EQUIP.	$15,283	5%	3%	$9,123
OpEx	$174,846	58%	35%	$106,424
PROFIT	$142	0%	10%	$30,409

If your CAPs felt like an ice bucket, this column feels like a warm ray of hope. Finally, we get to the delta, or the difference. For The Bleed column, we're going to subtract our PF $ from our Current $. If the result is a negative number, write "increase" in The Fix column. If it's a positive number, write "decrease." Ready?
- Owner's Pay: 85,635-106424 = -20,789
- Tax: 0-45,614 = -45,614
- Business Growth: 6,082-28,188 = 22,106
- Equipment -9,123-15,283 = 6,160
- Operating -106,424-174,846 = -45,614
- Profit: 142-30,409 = -30,267

Poppy's Instant Assessment

	CURRENT $	CAPS	TAPS	PF $	THE BLEED	THE FIX
REAL REV.	$304,094					
OWN. PAY	$85,635	28%	35%	$106,424	-$20,789	increase
TAX	$0	0%	15%	$45,614	-$45,614	increase
GROWTH	$28,188	9%	2%	$6,082	$22,106	decrease
EQUIP.	$15,283	5%	3%	$9,123	$6,160	decrease
OpEx	$174,846	58%	35%	$106,424	$45,614	decrease
PROFIT	$142	0%	10%	$30,409	-$30,267	increase

Now that Poppy has completed her assessment, she knows where she is (CAPs) and she knows where she is going (TAPs). She is ready to lay out her roadmap in the next chapter.

ACTION! **Just keep breathing.**
Take some time. I just tossed a bucket of ice water over your head. If this is starting to feel overwhelming or you can feel your heart beating in your chest and need to walk away, please do so now. In chapter one, I asked you to open one account and call it Profit. Keep that account and for every $100 in revenue you receive, move $1 over to your new Profit account. It's OK to give yourself some time to get over the shock. I'm here when you're ready.

CHAPTER 5

Your Profit First Roadmap

You can drive from New York to California. You can even do it at night, but if you do not have a map to show you the way, you might end up in Canada. Let's build your "roadmap" of how you're going to get from where you are (CAPs or your "before" photo) to where you want to be (TAPs or your "after" photo).

Planning Your Route

One of the most important things to account for when planning a long trip is the time it will take to get there. It is impossible to drive to California from New York in one day, and it would be incredibly dangerous to try. Similarly, when you create your roadmap, we never *ever* start at the TAPs. We're going to start by cutting just 2-3% from the "Decrease" lines on your CAPs. That will free up those percentage amounts to add to your "Increase" lines.

Remember the Instant Assessment we just did? For this exercise, let's tackle those Operating Expenses, using Poppy's assessment as our example:

	CURRENT $	CAPS	TAPS	PF $	THE BLEED	THE FIX
OpEx	$174,846	58%	35%	$106,424	$45,614	decrease

Right now, Poppy's Operating Expenses are at 58%, and we want her to get down to 35%, that's a 23% difference. If she were to just stop paying or accounting for those extra percentages right now, she would run the risk of killing her business. But if she can find a way to cut 2% to 3% in expenses

every quarter, she would be where she wants to be in two years. Here what that path on her journey would look like:

	CAPs	Q1	Q2	Q3	Q4	Q5	Q6	Q7	Q8	TAPs
OpEx	58%	56	53	51	48	45	42	39	37	35%

Now we'll take that same formula and apply it to every category. Boom! There's your roadmap, all planned out:

	CAPs	Q1	Q2	Q3	Q4	Q5	Q6	Q7	Q8	TAPs
PROFIT	0%	1	2	3	4	5	6	7	8	10%
OWN. PAY	28%	28	29	30	31	32	33	34	35	35%
TAX	0%	2	4	5	6	9	11	13	14	15%
GROWTH	9%	8	8	8	7	6	5	4	3	2%
EQUIP.	5%	5	4	4	4	3	3	3	3	3%
OpEx	58%	56	53	51	48	45	42	39	37	35%

So theoretically, the car is packed, the tank is full, your road trip playlist is ready, and you found your sunglasses. Now it is time to turn on the engine and get started heading west. As you go, you'll find many milestones along the way. Here's what you can expect on the first day, the first week, the first month, and the first year of your journey.

Day One: Your First Profit Allocation

You didn't start this process with $0 in the bank. Right now, you probably have a balance in the account that was your only business checking account, the one you renamed "Operating" in Chapter 3. If you haven't done this yet, what are you waiting for? Put the book down and go do it now. I'll wait for you.

NICKNAME YOUR ACCOUNTS

Now that you've got it done, let's go ahead and nickname the accounts to make it easy for you when you use online banking. We want some key

information in the nickname: the account label, the starting percentage (use the Q1 number, not the CAP itself), the TAP, and the last 4 digits of the account number. Here is Poppy's bank account nickname list:
- Income (5874)
- Profit (5628) / CAP 1 / TAP 10
- Owner's Pay (5843) / CAP 28 / TAP 35
- Tax (5798) / CAP 2 / TAP 15
- Business Growth (5739) / CAP 8 / TAP 2
- Equipment (5438) / CAP 5 / TAP 3
- Operating (5672) / CAP 56 / TAP 35

MAKE YOUR FIRST TRANSFER INTO YOUR INCOME ACCOUNT

Right now, you probably have a balance in the Operating account, since it was originally your only business checking account. Let's say the balance is $12,000, and you know bills are about to take $5,000 out of your balance, leaving you with $7,000. For your first transfer, you'll only transfer half of the remainder, or $3,500, to your Income account. (This is in case we forgot about something that might be on an autopay — we do *not* want this first allocation to cause you to bounce a payment! We'll talk more about buffer building later.) Then, either using the Excel spreadsheet you downloaded or doing the math yourself, divide that $3,500 into your accounts per your CAPs.

Here is how Poppy worked through this exercise. She had $15,946 in her operating account. She knew that a payment of $1,549 would come out of her account in two days, so that left her $14,397. She moved half of that total, $7,198.50, into her income account.

From there, she disbursed her income according to her CAPs:

Profit (5628): $7,198.50 x 0.01 = **$71.98**
Owner's Pay (5843): $7,198.50 x 0.28 = **$2,015.58**
Tax (5798): $7,198.50 x 0.02 = **$143.97**
Business Growth (5739): $7,198.50 x 0.08 = **$575.88**
Equipment (5438): $7,198.50 x 0.05 = **$359.92**
Operating (5672): $7,198.50 x 0.56 = **$4,031.16**

Going forward, all your deposits will accumulate in the Income Account until you allocate again, and at that time, we will use all the funds in the Income Account.

TELL YOUR MONEY PEOPLE

If you have a bookkeeper, accountant, or CPA, let them know what you're doing and why. You might get some pushback from them, and they may be hesitant to help you. They were probably taught the GAAP way of doing things, and Profit First pushes against that. If they haven't been introduced to this system, it can seem a little off kilter to them.

You need them on board with you, so be patient. Ask them to read the book, stay firm in what you want to do, and if they keep pushing back, I

have some options for you. You can hit the internet and look for another accounting professional. You can reach out to me directly at profitfirstforphotographers.com. Sometimes we have openings on our client roster to accept new clients. Profit First headquarters has also created an amazing resource you can use at ProfitFirstProfessionals.com.

Week One: Crop those Expenses

Zoom in on your business finances and see where you can make cuts. Start by collecting a list of all your expenses for the last 12 months and sort by "one offs" and "recurring." If you have a bookkeeper, they can help you. If you use accounting software, you can pull an expense by vendor report.

Total the list and then multiply by 10% (0.1). That 10% is what you must work on cutting this week. I know we're trying to do a few percentages each quarter, but it takes a while for billing cycles to reflect cancellations.

Now look through your list carefully, at all the people and businesses you make payments to. For each one, ask yourself: "Is this an *Ineeda* (I need it) or an *Iwanna* (I want it)?" The *Ineedas* are the essentials you must have in order to run your business, such as your camera, editing software, studio space (if you have one). The *Iwannas* are things like the lease for that luxury car, the cool software you only use once or twice a year, the membership for an association you're not active in; they're nice to have, but you can do just fine without them.

A few of the most common Iwannas for photographers are:

- **Software.** What good is spending $10 a month on a program you "might use someday" if that day never comes?
- **Dresses and props.** Many photographers suffer from what I call Sparkly Dress Syndrome. Maybe you love shopping for clothing and props "for your sessions," but clients never end up using them. Are you buying them for your sessions, or because you love to shop for them?
- **Equipment.** Don't get stuck in the thought process that some shiny new equipment equals a magic transformation in the work you can produce. You as the photographer are the magic; and you as the business owner must protect the profitability of the business.

With recurring expenses that are *Ineedas*, you might be able to find other options or renegotiate terms with the vendor. If it's an *Iwanna*, let it go.

Raising your revenue will also affect the percentages so you don't feel like you're cropping out too much. However, raising the revenue is a slower game and can take longer to see the rewards. Do not depend on this when doing your initial crop.

When Poppy looked at her list, she quickly found three subscriptions for software she didn't even use and canceled them. In all, she cut more than $700 per month ($8,400 per year) in *Iwannas*, lowering her operating expenses by 5% and instantly exceeding her goal of 3% for the first quarter of implementation. Win!

Month One: Finding Your Rhythm

It's more appropriate to call this Day One of your Allocation Schedule. This is where we do the same exercise we did on day one, only we're going to do it for the funds that have accumulated in your income account, and we're going to do it twice per month from here on out.

Some do it on the 10th and 25th, some do it every other Friday. The details of the day aren't what I want you to focus on. What matters is that you have a rhythm. Remember Jason and his money being lost in cyberspace?

One way to set up a rhythm that feels natural is to schedule it at the same time you're already doing other money tasks. If you're already in the mindset of bills and admin work, your allocations will quickly become part of that habit. I personally do the 5th and the 20th because that's when I'm running payroll.

Once your allocations are complete, it's a good time to check the balances in your Owner Pay and Operating accounts, which money flows out of regularly. If you have enough money to cover your paycheck and pay your bills, you're good. If you have more than enough, only take your usual paycheck and leave the remainder as a buffer. If you do not have enough in your Operating account to cover the bills, you need to categorize this as "Houston, we have a problem" time. Your business is screaming at you that something is not OK; it can't sustain itself, and you need to do the crop exercise again.

CLIENT VIGNETTE: JENNIFER'S PROFIT FIRST LIFE

"I think it has taken me years to get out of the mindset that I have to take any picture of anyone who wants their picture taken. I no longer must hustle for every dollar."

Jennifer remembers the days when a client would pay her $600 and she would wait about 10 minutes after the client left to close the business and run to the bank to deposit that payment. She knew it had to be deposited right then because vendor payments were coming out of her bank the next day. She was literally stuck in a check-to-check situation.

During my conversation with her, Jennifer laughed as she looked around her desk and admitted that there was a payment that has been sitting on her desk for days. She doesn't have to rush it to the bank, so she keeps forgetting to.

SECURITY TIP
Build Your Buffers

In 2020, when the pandemic began, businesses really struggled to stay afloat. The businesses that didn't have extra funds, or buffers, in the bank quickly went under. I'm sure you can agree that it was heartbreaking to watch so many people lose everything they had worked so hard to build.

Buffers are important, but how much buffer do you really need? A good rule is six months' worth of expenses in both your Operating and your Owner's Pay accounts. If you have that, you know that if something crazy happens and your cash flow suddenly dries up, your business and your family will be OK.

No, the six-month standard wouldn't have been enough to last you the entire pandemic, but it would have bought you more time to adapt to new circumstances or correct what went wrong to try and get the ball rolling again. Photographers weren't considered essential businesses; they couldn't have photo sessions because of social distancing restrictions. Out of necessity, some of them got creative and launched online courses for sale. The available online photography education spiked in the fourth quarter of 2020. Now, even post-pandemic, they are still strong revenue streams for photographers. Imagine who might still be open if they had six months to pivot and readjust the way their revenue stream was set up.

You will want to review these buffer balances at least once per quarter to make sure they're still in line with where they need to be.

Since she started with Profit First, Jennifer has increased her monthly paycheck from $800 to $3,000. The first thing she did was make sure that she had six months of her current salary in the bank as a buffer. At the start of a quarter, she increased her monthly pay $200 and, if she can still maintain the buffer through the whole quarter without adjusting the allocation percentage, she does another increase. This is one way that she uses the power of Profit First for communication between her and her business.

Implementing Profit First prior to the pandemic and getting those habits in place has been magical for Jennifer. Reverse engineering the numbers and harnessing the power of percentages, Jennifer has set aside some funds to build a new studio in the lot next door, 2,400 square feet of usable

space for studio and storage. She was able to purchase a brand-new business vehicle for the very first time in her life.

Jennifer is very proud to say that she is now the "breadwinner" in the house. "I never would've thought that I'd have over $100,000 sitting in the bank. Yes, I have more money coming in, I've raised my paycheck, plus the business is covering a car payment. I'm saving more money because I'm managing my money better."

Quarter One: Profit Distribution

It's a brand new quarter, and you know what that means: you're going to issue yourself a distribution check! Woo-hoo!

This is very important. Do not skip it. Your Profit Distribution is your reward for owning and operating a financially responsible business. (Not to be confused with your owner's pay, which is your money for doing your job). It's your business working for you instead of you working for your business. It's your Return on Investment (ROI) of the time, sweat, and money you've invested in your business. The best part is, you get to do this four times a year!

> Here is what that schedule looks like.
> Quarter 1 – January 1 to March 31 (Distribution Day April 1)
> Quarter 2 – April 1 to June 30 (Distribution Day July 1)
> Quarter 3 – July 1 to September 30 (Distribution Day October 1)
> Quarter 4 – October 1 to December 31 (Distribution Day January 1)

For your Profit Distribution, you're going to take 50% of whatever is in your Profit Account. The remaining 50% is going to be another buffer, and it's going to grow with the following quarters' allocations so that, ideally, every Profit Distribution check is more than it was in the prior quarter.

Let's say in the first quarter you have $1,000 in your Profit Account. You take $500 of it and put it in your pocket. Through the next quarter, you allocate another $1,000 into your Profit Account. On distribution day, you now have a balance of $1,500, so you can now put $750 in your pocket. And the cycle just keeps going. That's how your profit distribution can grow every quarter.

COURSE CORRECTION: ADJUST YOUR LENS
The new quarter is also the time to take another look at your CAPs. Compare them to your roadmap and adjust accordingly for the upcoming quarter — and expense sheets.

Adjust those percentages conservatively. You don't want to get in a situation where you have to backtrack. You always want to be moving toward the TAPs, and it's easier if you take small steps instead of huge leaps.

WHAT DO I DO WITH MY PROFIT DISTRIBUTIONS?
What makes you happy? If it makes you happy to shop, then shop. If it makes you happy to contribute to your retirement, then contribute to your retirement. If it makes you happy, then you will want to do it again. If you want to do it again, then you will stick with the Profit First implementation. See where I'm going here?

Security. My clients spend their Profit Distribution in different ways. Some want to have more cash on hand. Being a child of the 90s, and a somewhat fan of hip hop, Sam Garcia felt like there was a certain "flex" about having "a rack"— commonly known as $10,000 cash in hand. But he wasn't just looking to "flex," he was also thinking about so much more: the safety of his young family and securing a happy future for his children.

The feeling of safety that comes with having that cash on hand in the event of an emergency is the same feeling that comes with keeping fire extinguishers in the house, or a blanket in the trunk of the car (if we live in cold climates) in case we break down on the side of the road. It just made sense to him.

Opportunity. As an entrepreneur, you might be happy to uncover new opportunities, and you never know when they might come knocking. Sometimes when they knock, they don't stay very long, and you have to act fast. You want to have cash readily available before you answer the door.

To Sam, banded stacks of crisp $100 bills from the bank is a "tangible, physical representation of becoming profitable." Knowing he has cash literally on hand, secure in his home should the need or opportunity arise, gives him peace of mind and helps him sleep better at night.

Luxury. Amy was both nervous and excited when we started to implement Profit First. Distribution Day was coming, and through her hard work and discipline, she knew it was going to be a good chunk of change. She carefully considered what she could do with that money. Amy always felt weighed down by the responsibility of being a wife and mom and supporting her family. She struggled with the idea that she deserved nice things. During her entire career, she wanted a Louis Vuitton work bag. She always admired those bags from afar but never could "justify" (isn't it crazy how we feel we must justify things we spend our money on?) the expense.

The following week after Distribution Day, Amy was out shopping with a friend when they walked by a Louis Vuitton store and decided to go in. She looked at the bags and fell in love with the black one that was the perfect size and structure for a work bag. It could hold everything she needs on her workday. She had looked at other bags in other stores, but they just weren't "the one." Here at the Louis Vuitton store, she finally found it. Just like it was meant to be. She purchased it and took it home.

She let her prize sit out on the kitchen counter for five days before removing the bag from its packaged box. She would walk by it throughout her day and tell herself she should return it and then talk herself out of returning it. On the fifth day, she finally unpacked it from its packaging and decided that, yes, she deserved it.

You see, the bag wasn't actually an "expense." She it was an "investment" in a quality work bag she will love and carry for many years to come.

Experiences. Some of my clients use their Profit Distributions for trips. When Felicia and I started working together, she said she wanted to take a trip once a quarter, and she did. She saw friends in different states, then started to take trips abroad. One time, she used two distributions to fund

a once in a lifetime trip to Paris with friends. Another time, she went with her close business circle to a resort in Mexico. At the time of writing this book, Felicia has been saving her distributions and is preparing for a trip to Belgium, where she will vacation and be photographed by one of her mentors. She has wanted this for a few years and will finally be able to make it happen.

In the past, Jennifer has used her distribution to pay for her husband to accompany her on a five-day business trip to photograph a client in Greece. She has created a list of things she wants to do with her distributions, which include new furniture for the house and trips with her family, such as Hawaii and Iceland.

Year One: Progress Photo

Congratulations, you made it through your first year! By this time, you are well on your way to your TAPs (after photo). If you need a pick-me-up, I recommend going back to Chapter 5 and redoing your assessment. You will be pleasantly surprised and not shocked. No ice buckets.

TAX TIME

Hours of productivity and sleep are lost every year by worrying about the things having to do with the tax man. The consequences of not paying your taxes are steep, and lives have been ruined by that one thing. I don't want you to go through that. The ability to pay your appropriate amount in taxes on time and not worry about where the money is coming from is a freeing feeling.

First, you need to remember that having to pay taxes, while no one likes it, can be a good thing. It means you're making money and have a successful business. Also, we want to pay the appropriate amount and not overpay. We aren't tipping the Internal Revenue Service. They aren't serving us drinks or bringing our dinner. With that being said, please make sure you have a tax professional who is in tune with your goals and knows how to properly prepare your tax returns.

Chapter 5: Your Profit First Roadmap 65

You may have noticed in Chapter 4 when we were discussing TAPs, the percentage to allocate to your tax account is 15%, no matter which revenue bracket you're in. I know, you have probably heard that you need to put 25% or 30% of your money aside for taxes. Depending on your case, you may pay up to 38%. Stay with me; I've asked Poppy to help me explain why the 15% works.

Let's revisit her numbers from her Instant Assessment:

	CURRENT $	CAPS	TAPS	PF $	THE BLEED	THE FIX
REAL REV.	$304,094					
OWN. PAY	$85,635	28%	35%	$106,424	-$20,789	increase
TAX	$0	0%	15%	$45,614	-$45,614	increase
GROWTH	$28,188	9%	2%	$6,082	$22,106	decrease
EQUIP.	$15,283	5%	3%	$9,123	$6,160	decrease
OpEx	$174,846	58%	35%	$106,424	$45,614	decrease
PROFIT	$142	0%	10%	$30,409	-$30,267	increase

There are three lines here that would be considered expenses that she can write off when preparing her income (not revenue) tax return: Business Growth, Equipment, and Operating Expenses. On top of this, she can also write off her Cost of Goods Sold (194,420).

Her total write-off for business expenses is $417,737. Her total business revenue is $498,514. She will have to pay taxes on the difference of $85,777. In case you didn't notice, that's also the total of her profit and owners pay.

Because of her joint tax return with her spouse, Poppy is in the 35% income tax bracket. Together, they had a tax liability of $42,846, of which $30,022 came from her business income.

Let's go back to the 25% or 30%. It's not that this number is *wrong*, it's that it's not clear. What is that a percentage of? Depending on who you ask, you might get different answers. Let's say Poppy was told to hold 25%

of her Top Line Revenue, or total business income. Her Top Line Revenue is $498,514; 25% of that is $124,628 — almost three times what she would actually need. OK, what about her Real Revenue ($304,094)? A quarter of that is $76,023 — still almost twice what she would owe. Imagine what she could have done with that money if it wasn't sitting there waiting to pay a tax liability that she would never have.

On the other hand, basing it on what she took home doesn't work either. Looking at her Owner's Pay and Profit (we're not going to think about the tiny profit number here), Poppy took home $85,635. If she set aside 25%, she would have accumulated $21,409, just half of her liability. Yikes!

The Tax account is intended to cover tax liability for both business *and* business owner. While the 15% might sound confusing, it works. Had she been implementing Profit First, Poppy would have set aside $45,614 for taxes. That's a 6.5% surplus of the $42,846 they owed — just enough to cover anything unexpected.

Keep in mind that it's not an exact science. Everyone's tax returns are different. While there are many other variables that can come into play when calculating your income tax liability, it's pretty close and can keep you out of hot water. Try it sometime with your own numbers.

CLIENT VIGNETTE:
FELICIA'S TAX STORY
Nine months after implementing Profit First in her business, Felicia and her husband, Alan, went to the CPA to have their yearly tax returns prepared. This was the first year Felicia had made a profit with her photography business, and that meant extra taxes were due — a lot extra. As the CPA finished filling out all the forms and calculating what was due to the IRS, Alan was not expecting what was about to come out of the CPA's mouth: "You owe $17,000 in taxes this year."

Prior to working in photography, Felicia and Alan both had successful careers in the corporate world. They made good money, but since they worked for other companies, the taxes were always withheld from their paychecks. This particular year, they had Alan's W2 income with taxes withheld, but Felicia's income came in the form of self-employment, and taxes weren't withheld throughout the year. "I don't know where you think you're going to get that money from," Alan said.

"But it's a good thing," Felicia explained. "The more money you owe the tax man, the more money you made. That means that we made a lot of money."

"I don't care. I don't know where you're getting that money from."

Felicia just touched Alan's leg and, in a loving voice, said, "Be calm. I got this."

Now, Alan had never paid much attention to the business aspect of Felicia's business. He didn't know she had implemented Profit First and had been putting money aside for this very reason. Felicia showed him the bank account with the money in it, and then she wrote the check.

In that moment, Felicia felt proud. First, she had made enough money to have to owe $17,000 in taxes. Second, she was independent and have a legitimate business. Third, there was not one worry in her body.

Now every year when it's tax time, Alan doesn't even flinch because he knows that his wife has it covered. Taxes are no longer a stressful event in their lives. It's just a matter-of-fact thing that they do. That's what I want for you.

ACTION! **Mark your calendar.**

I mean it; literally open your calendar and add a few things. Allocate according to the rhythm schedule you set up (takes less than 10 minutes). Mark your four distribution days (takes less than five minutes). Block off time once a quarter, usually right around distribution day, to dive in and adjust your percentages accordingly and review your expenses. (You might need 30 minutes for this one.) If you put it on the calendar, you're more likely to do it.

CHAPTER 6
The Big Picture: CEO Mindset

It was about 20 minutes before I would be giving a presentation to a group of 70 creative entrepreneurs, on the exact information I'm teaching you here in this book. Everyone was starting to file in and mingle. That's when I met Alyssa McDonald. "What brings you here today?" I asked her. "What is your burning question that I might be able to answer?"

Alyssa had been a wedding photographer in Colorado for eight years. She admitted to me, but more importantly to herself, that she had absolutely nothing to show for it. She gestured to all the other people in the room, with tears filling up in her eyes, and said, "How do all these people have their act together when I can't seem to pay a bill on time?"

Placing my hand on her arm, I told her, "If your question is not answered by the end of this talk, please come see me afterward. You and I will sit down to talk about your specific numbers."

When the presentation was complete, she rushed up to the front and hugged me. "I get it."

"You get what?" I asked.

"I've been doing everything backwards, I've been hampering myself; I am the reason that my lifestyle is the same as a poor college student."

After a few minutes chatting with her, I made sure she had all the printouts that corresponded with my presentation, and we said our goodbyes.

Fourteen months later, I received the following email:

Venus,

I want to thank you again for coming and talking with us last year. The information I learned that day changed my life. I am happy to report that I took my first profit distribution a few months ago. I am also paying myself and my bills on time. My revenue has increased 120% over last year. I think you not only saved my business, but you saved my life.

Eternally Thank You,
Alyssa

Alyssa is an amazing photographer, but she lacked the knowledge of how to run her business. She was taught to look at her business through the wrong lens. All she needed to do was take a breath, reframe what she was looking at, and refocus on where she wanted to be.

"Where Can I Find the Money?"

Have you seen that internet meme of Captain Jack Sparrow yelling, "Stop blowing holes in my ship"? I think of that meme every time someone asks where they can find the money. Picture this: Your business is a ship on the ocean. You're surrounded on all sides by expenses, all armed with cannons. Their goal is to sink your ship, and your goal as Captain is to defend it. But they're going to hit you with everything — not just vendors and bills, but also sleek new equipment, or that sparkly dress you simply *must* have for your props closet.

A lot of photographers struggle when it comes to learning how to navigate this aspect of business. There is a wealth of courses, mentors, and trainers to teach you how to take a photo, adjust lighting, pose subjects, and even price services, but no one is talking about what to do in the back office. To keep your business in ship shape, you must up your game and pay attention to the stuff outside of the view of your camera. Let's talk about that stuff.

PLUGGING THE HOLES
Look over that expense by vendor report we pulled in Chapter 5 again. Inspect it for payments and vendors that are *Iwannas* blowing holes in your

bank account. Remember Parkinson's Law? When you were first starting out, you didn't have all these expenses, but you still got the job done. Which ones aren't helping you get the job done now? Can you cut some of those even temporarily? Look at the difference between your CAPs (Current Allocation Percentage) and your TAPs (Target Allocation Percentage) to decide what needs to go first.

INSPECTING THE HULL
If you wait until your tax return is due to review your numbers, you have waited too long. It's important to review and understand the financial health of your business at any given time. That can be a massive undertaking if you don't have a bookkeeper who sits down faithfully every month and reviews your financial statements with you, while making sure you as a creative truly understand the story that the numbers on the page are telling. Even if you do have that person, you may not have the time or desire to devote to that meeting. That's exactly why Profit First is the perfect tool to use. The system you just learned about is the way your business communicates with you in real time, showing you things that might need your attention. Looking at the financial statements once a month is also important to give you a bird's eye view of the entire big picture.

HIRING THE RIGHT CREW
When you think about hiring someone, an admin, an associate photographer, an on-staff editor etc., there are a few things to think about. First, do not hire for the sake of hiring. Think about the purpose of the new position. What are they going to do for you? What are they going to take off your plate? How much time are you going to get back to work on other things? How much will your real revenue increase by having them as a resource on your team? Do you want them there full time or part time? Once you have gathered all of your answers, that is the time to sit down and consider what you're going to pay for this position. And if it will benefit you, move forward with the hire.

Bank Access for Users. Imagine you've hired an assistant to help you handle the parts of your business that you don't have time or desire to do yourself.

Chapter 6: The Big Picture: CEO Mindset 71

One of those things is banking. So, you give your assistant your bank login because you're just too busy to deal with it. Why pay the fee for multiple users?

First of all, you should never be too busy to deal with your money. Second, it's not fair to put an employee in that position. They may not feel comfortable taking on that liability, or worry about being blamed if something happens to the account. Third, compare it to giving out your debit card and PIN number, and then trying to claim fraud when your account

To keep your business in ship shape, you must up your game and pay attention to the stuff outside of the view of your camera.

is drained. If you willingly give your user ID and login to anyone else, that person has full and legal access to do all kinds of transactions, not just the ones you want them to do.

Let's say your assistant decides one day that you don't pay her enough. So she begins to Zelle herself an extra $50 a week. Six months and $1,300 go by before you finally notice. Can you go back to your bank and say, "Oh my gosh, fraud?" No, not really. You literally gave them the keys to the castle. You could file a police report, but there's no guarantee that anything will be done about transactions that weren't actually fraudulent.

If you give your employee their own user login, you get to pick what they have access to. You also have the ability to revoke access as you end relationships with people. If your assistant has their own login and then you part ways, you just go into your online banking and delete that profile. You don't have to worry about whether they know your password.

The Lookout: Hiring a Bookkeeper. As with anything involving your money, there are a lot of emotions tied to hiring a bookkeeper. The most common emotions I hear about are vulnerability, embarrassment, and fear of judgment. Opening up your pocketbook to a stranger can sometimes feel just like that nightmare people have of showing up to high school without your pants.

Remember that accounting is an analytical task, and you as a creative person may struggle with that task. I'm the total opposite of that; I have a fancy DSLR camera and three lenses I enjoy playing with, but there's no way I could take photos like you do. To be totally honest with you, I use auto mode. In the same way, you might have a subscription to an accounting software, but I wouldn't be surprised to hear that you don't understand how to harness the power of it.

The 5 Software Mistakes of DIY Bookkeepers

Should you decide that hiring someone else is not the right fit for you right now, I still want to set you up for success. Let's go over the top five mistakes I've seen photographers make when DIYing their bookkeeping, so you can avoid them.

MISTAKE 1: Failing to balance debit and credit.
As a photographer, you're adept at capturing the perfect balance of light and shadow in your images. In the world of accounting, debits and credits are somewhat like this balance, essential for maintaining the financial stability of your business.

Debit. Imagine you're buying a new camera lens for your studio. When you pay for this lens, you're essentially reducing the amount of cash you have on hand. In accounting terms, this decrease in cash is recorded as a debit. Debits will represent an increase in assets (like inventory or equipment) and indicate a decrease in liabilities and equity (like paying off a loan).

Credit. Now, let's say a client pays you for a photoshoot. This transaction increases your bank balance. In accounting, this increase is a credit. Credits signify an increase in liabilities (like a new loan for studio equipment) or equity (like your earnings). They also reflect a decrease in assets (when you use cash to pay a bill).

In Profit First, every transaction affects two accounts: one must be debited, and the other credited. For example, let's say Poppy purchased a new camera for $3,600: In her accounting software, her transactions were recorded as follows.

Debit Equipment Account
Credit Cash/Bank Account

As a photographer, you have an eye for detail, but if this is a blur, don't hesitate to consult a professional bookkeeper or accountant. Understanding and managing your debits and credits effectively can give you clarity and can be just as rewarding as capturing that perfect picture!

MISTAKE 2: Mishandling the Profit First bank transfers.
So, you're starting to implement Profit First, you have your bank accounts set up, and you're transferring your money between them. Those transactions are being downloaded into the accounting software, but how do you deal with it from there? The mistake I see all too often is that the DIYer will record the transaction as a deposit, since the money was deposited in

the profit account from the income account. That would be wrong. If you record it as a deposit in your software, it gets recorded as income, but it was already recorded as income when those funds were initially deposited into the income account. In other words, this mistake will cause your income or sales amount to be inflated. On the other side, where the money has left the income account, the DIYer often records it as a general or uncategorized expense.

Every accounting software has a transfer function, and as long as you record your Profit First allocations using the transfer function, and not the deposit or expense function, you should be able to avoid this costly mistake.

MISTAKE 3: Lumping everything in one account category labeled "Office Expenses."

Understanding the Chart of Accounts, much less building it out to suit your needs, can be a cumbersome task. Picture your Chart of Accounts as a file cabinet with each section as its own drawer. There are five drawers:

1. Bank and Credit Card Accounts
2. Assets and Liabilities
3. Income
4. Expenses
5. Equity

Each drawer has a set of hanging file folders that each represent an account on your Chart of Accounts. If you don't have enough hanging folders and you keep cramming papers in them, they may become too full and break.

That's probably what most DIYers' folders look like — it's all too common to just have one account labeled "Office Expenses." The problem is, there's a lot that can go into that category, such as office supplies, cleaning supplies, software subscriptions, and that new desk chair. Yes, they are all technically office expenses, but grouping them together can hurt you later on when you're trying to calculate how much you actually spent on software subscriptions (the main culprit in leaking money from a business).

Chapter 6: The Big Picture: CEO Mindset

If you split those four expenses into their own categories, you will be able to see trends in your spending, and with minimal time and frustration, you will know exactly where your money is going. If you know exactly where your money is going, then you can keep your expenses low, therefore keeping your operating percentage low and enjoying the benefits of implementing Profit First.

Some DIYers instead make the mistake of having too many categories. I once helped organize a client's Chart of Accounts who, instead of a "Software Subscriptions" category, had made a separate category for each

Understanding and managing your debits and credits effectively can give you clarity and can be just as rewarding as capturing that perfect picture!

subscription — 17Hats, Canva, QuickBooks, Google Storage, App Sumo, Slack, Zapier... you get the point. He had reached the point of frustration where he didn't even care to know how his business was doing financially because the reports did not make any sense to him. Every time he printed his P&L, it was 13 pages long. After I condensed his Chart of Accounts and realigned his reports, the P&L was the expected two pages to print.

MISTAKE 4: Forgetting to reconcile the software to the bank.
Reconciling your bank statements with your accounting software is a critical step in catching any discrepancies, errors, or even fraudulent activities. Just as you wouldn't overlook a smudge on your lens, don't overlook the small transactions that might indicate bigger issues. Monthly bank reconciliation ensures that the financial health of your business is accurately reflected in your books. This process is akin to reviewing your photos after a shoot — it ensures that what you captured (or spent) aligns with what you intended.

Regular reconciliation helps you keep track of your cash flow, ensuring you're aware of which payments are due and when. This awareness can help you plan for future expenses. It can also help with your tax compliance. Reconciling your bank statements with your accounting software ensures that every transaction is accounted for. It can also be very helpful in case of a surprise, like a tax audit. I broke it down into four steps for you:

1. ***Gather Your Documents.*** Start by collecting your latest bank statement and accessing your accounting software.
2. ***Compare Transactions.*** Review each transaction on your bank statement against those recorded in your software.
3. ***Identify Discrepancies.*** Note any differences between the two records, such as missing or incorrect entries.
4. ***Adjust and Record.*** Make the necessary adjustments to reflect the accurate state of your finances.

By making bank reconciliation a monthly ritual, you're not just aligning numbers, you're fine-tuning the focus of your business's financial lens, ensuring clarity and precision in every aspect of your financial management.

MISTAKE 5: Forgetting About the Merchant Fees
Your business often involves frequent transactions through payment processors like Stripe or Square to understand the nuances of bookkeeping, especially when it comes to electronic deposits and associated fees. Recording only the net amount (actual deposit amount) of electronic deposits without accounting for those fees can lead to a distorted view of your financial health. Simply recording the deposited amount as sales doesn't give you the full picture of your earnings. It's like editing a photo but ignoring the shadows; both elements are necessary for a true representation. Similarly, merchant fees are a cost of your sales and should be recorded to reflect your actual gross revenue. You want to have a complete picture of your true revenue in order to stay on track with your Profit First roadmap.

Neglecting to record merchant fees can also lead to inaccuracies in your tax filings. These fees are typically considered tax-deductible business expenses. By not recording them separately, you could potentially inflate your taxable income and end up paying more in taxes than necessary. Your financial statements should accurately reflect all aspects of your business's financial activities. When merchant fees aren't accounted for, your profit margins can appear higher than they actually are.

Understanding the true cost of doing business, including transaction fees, is crucial for effective budgeting and forecasting. If these costs aren't separately accounted for, it can be challenging to anticipate future expenses, much like working on your package pricing without knowing how much it's going to cost you just to get your money in the bank before you do anything with it.

Maintaining a clear and detailed bookkeeping system reflects your professionalism and credibility as a business owner. Just as a well-organized portfolio presents you as a credible photographer, well-organized books showcase your commitment to all aspects of your business.

There are two steps to maintain a clear financial picture:
1. **Separate Gross Sales and Fees.** Record the total amount billed to the client as your sales. This is the gross amount before any fees, and it's the

total money your client paid for your service. If your package is $4,000, then that's the number used here. This is not the total that was deposited or the total they may have actually paid if there is a sales tax amount on your invoice.

2. **Record Merchant Fees as Expenses.** Enter the fees charged by the payment processor as a separate expense. These are the costs associated with capturing your sales (usually around 3%) that the processor will charge for their service and typically will withhold it from your deposit.

By following these steps, you ensure that your financial records are as detailed and accurate as the beautiful images you create. This precision not only helps with financial clarity but also with strategic planning for the sustainable growth of your photography business.

CHAPTER 7

Profit Your Way Out of Debt

No, I have not lost my mind. I know this chapter is talking about two opposite things. You may think that if you're going to implement the Profit First system, you cannot have debt or finance anything. Let me debunk that thought right now. Carrying debt is not a good feeling and can cause a lot of stress. However, financing, if done responsibly, can help you get to where you want to be.

Now what I don't want you to do is sell off all your expensive equipment and put your business in jeopardy. Well, maybe we take a second look at your wardrobe/dress closet. But really, getting rid of debt should feel good and make you excited for your future again.

Get Out of Debt: The Snowball Method

I like Dave Ramsey's advice when it comes to paying off debt. He teaches what is called the "debt snowball" method: You start by paying off on the smallest debt, not the largest interest rate. Sounds backward, right? But trust me, it works.

Remember, money is more about emotions than transactions. It's not about the numbers, it's about the emotions. Dave also uses the system of quick wins; a quick win will release your feel-good hormones. If you feel good about something, you want to keep doing it. That's why it's important to start small, so you can get that first win.

Start by listing all your debts from smallest to largest. Make the minimum payments on all your debts except the smallest one. For that one, you will be hyper-focused on putting all of your extra available money toward it until it's paid off. Once the smallest debt is paid off, you win! It's time celebrate, so you will want to keep doing it. (I do what I call a "ripping ceremony," where I take the statement of the debt I just paid off and tear it to pieces.)

Now the second-smallest debt on your list has become the smallest, so you hyper-focus on that, pay it off, and celebrate again. Now it's time for your third-smallest.

You see where I'm going with this? Every time the list shrinks, you have one less minimum payment every month, which means you have more to put toward the next debt. That's how you build your debt snowball.

CLIENT VIGNETTE
Susan's Snowball

When Susan started working with me, she'd accumulated more than $60,000 in business credit card debt across seven cards, and six of them were maxed out. "I feel like I'm drowning and can't catch a break to save my life" is what she told me one day. She said she wasn't even charging anything to the cards anymore, but was still paying about $2,500 a month to the credit card companies. Then she asked me what my thoughts were on declaring bankruptcy — oh, that's a word we don't like to hear.

"Let's set that thought aside for a month and see what else we might be able to come up with," I said. After her reluctant agreement, I immediately started diving into her cashflow, budget, and debts. On a Tuesday morning, I called her.

"Susan, I want to Dave Ramsey your debt."

"Does that mean we have to put Profit First on hold?"

"No, not at all! I got you. Not only do I have a plan to get rid of this debt, but I found another $500 in your budget we can put toward it."

I told her I was going to send her an Excel file and started to explain my plan. We were going to tackle the credit cards in the order on the excel file with the budget of $3,000 a month.

The total minimum payments were $1,820.50, leaving $1,179.50 to put toward the smallest balance. I gave her a plan to have the debt paid off within two years, and guess what? She got it done in 15 months. As the balances went down, the interest was lower, so more of her payment was going to the principal. Some months she had more than what was budgeted to apply toward her debt and made extra payments accordingly. She still has two of the six credit cards today, but she never carries a balance on them.

Stay Out of Debt: Business Financing 101

Business lending doesn't work like personal lending. Sometimes, even if you have a lot of money and the right credit score, you'll still hit a roadblock if you're looking for the wrong kind of loan for the wrong reasons.

Secured loans, unsecured loans, and lines of credit (LOC) may not seem that different to the average person. But they are different banking products. They have different purposes. They have different rates and terms. You need to know and be able to explain to the bank why you're asking for debt.

I want to be very clear here. Loans and LOC are debt, and we really do not want debt. However, they can also be helpful tools, as long as you pay them off aggressively and stay within budget. You might want to consider opening a separate "debt" bank account and allocate a percentage just for that. Let's talk about financing and the different options here.

SECURED VS UNSECURED LOANS

Let's say you frequently deliver your products to your clients or have your sessions on location, and want to buy a car in your business name. That car would be collateralized (or secured) debt — something tangible that a lender can repossess if you default on the loan. Rates on secured loans are lower than unsecured loans because the loan is safer for the bank.

Now let's say you want a loan for something less tangible; your business partner is ready to retire, and wants you to buy her out. Because there is no collateral, the bank has nothing to secure if you default on the loan. It's a higher risk for the bank, so the interest rates will be higher.

Sometimes banks try to secure certain unsecured loans by using cash as collateral. In such instances, they might require $20,000 in cash as security on a $200,000 loan. This $20,000 doesn't reduce the loan amount; it's for the bank to hold in reserve should there be a default on the loan.

LOANS VS LINES OF CREDIT

A loan is a one-time deal; you receive the money in a lump sum and have to pay it back within a certain amount of time. A line of credit is like a revolving loan. The total loan amount is available to you, but you can borrow from it repeatedly

in varying amounts, similar to a credit card. An LOC is something you would use when you need to buy inventory that's going to take you a while to sell.

Because you borrow only what you need for only as long as you need it, your monthly payments could be a lot lower. However, you're going to pay higher rates, usually an additional 1-2% on top of prime. As of the writing of this book, prime is 8.5%. That means a line of credit is 9.5-10.5% variable. As prime goes up, your rate goes up. As prime goes down, your rate goes back down. But again, sometimes that's just the right solution for someone. Plus, you might be able to get an introductory offer that's below prime.

"How much do I ask for?" This is probably the most common ask that bankers get, the "I want a line of credit for some amount of money." The typical turnaround time, from application to funding, is 30 to 60 days, and the more money you ask for, the more difficult it can be to obtain. In personal lending, most people will just apply and see what they get approved for. But that's not how business lending works. Normally, you can qualify for 10% of your annual sales. If your annual sales are $100,000, they're probably going to offer you a credit card instead. Not many banks are going to give you a $10,000 line of credit because that's not the right use for that. They will instead give you a credit card. Once you hit closer to $250,000 in annual sales, the bank might consider a line of credit. Sometimes you can get approved for a $50,000 line of credit through an online bank. Just be careful of the terms. How much are you going to pay and what are the annual fees?

BUSINESS CREDIT CARDS
Credit cards are generally a safer way to spend money than debit cards, since rectifying credit card fraud is a lot easier. With bank fraud, although you typically get that money back within a couple days, sales and expenses are still happening within those couple days. Are you ready to run payroll? What about the vendors that you just sent payments to? Having the cash in your checking account tied up in a fraud claim can make your business miserable.

So, credit cards are the way to go. But you shouldn't use your personal card either. When you use your personal card for business expenses, you rack up debt that was to be business debt, which will affect your ability to

borrow personally. With that being said, make sure you do your research about which banks report business debt on personal credit reports. Because of COVID, some national banks that offer business credit cards began to report business credit card debt under personal credit reports. And that affected those personal business owners who wanted to buy a house or buy a second house and, suddenly, their debt looked astronomical. No matter how great their credit scores were, lenders technically aren't permitted to pile on more debt. Since 2008 and 2009, they cannot over-lend to people anymore. It's part of the financial reform that went through years ago.

What do business credit cards have that your personal card doesn't? Two words: Multiple cardholders. If you're just handing your one personal credit card to your assistant, you're opening the door for so much to go wrong. What happens if they lose it, or they use it for something they shouldn't, or it gets stolen? Now you have to cancel your entire personal card and wait for a new one. With a business card, you just cancel that one compromised card, get a new one, and move on.

You can also control the credit limit for each cardholder individually. You can have a $100,000 credit limit on your own card, but set your assistant's card to have only a $500 limit. You can also move the credit limit up and down as you see fit. And you can do it all online, which is an added value because it's easy to do.

Credit Cards with Rewards. If you're going to put your expenses on a credit card, you might as well find one that gives you a reward. Make your money earn you money. The most common and versatile reward is cash back. Whether you use it to fill your gas tank or go on a Cyber Monday shopping spree, you get rewarded for spending money. You can also elect for a statement credit, which will leave more money in your checking account. Bonus!

Alternatively, if you travel often, you can earn rewards for something you're already doing. Most institutions, especially the top 10 largest ones, have business travel rewards cards. The usual deal is earning one travel mile for every dollar spent. Some institutions will offer two or three miles for every dollar on a certain type of purchase. You can go to websites such

as bankrate.com and look at all the travel rewards cards out there and figure out which one you want to use. (The nice thing about cash rewards is if you want to use them to travel, you can!)

Another thing to mention is a lot of institutions offer rewards on top of the rewards, most commonly a 10% kicker when you redeem your reward. In other words, if you have 1,000 miles to cash in, you'll actually get 1,100 miles; if you have $100 in cash to redeem, you actually get $110 because.

Different banks have different levels of kickers, but it's always dependent on how much money you have invested with them.

This works out great when you have your business credit card and Profit First accounts at the same bank. They don't care what you're saving your money for; they care that you have all that money with them. You can leverage that for a business credit card with a more attractive reward program.

Know Your Score: Business Credit

Did you know that your business has a credit report? We know that we, as consumers, can access our credit reports through the credit reporting bureaus, but we can also use them to access your business credit.

When you go to a financial institution for business financing, they will pull your business information from a few places to see what debts are being reported, what balances you're carrying, and what your payment history is. Trade lines may or may not be reporting your credit, so if you open one, check their reporting policies. One of the three major credit bureaus is only a piece of that pie.

TRADE LINES

Now you're probably asking what in the world a trade line is. Trade lines are generally associated with contractors and blue-collar labor, such as people who purchase a lot of supplies like lumber, marble, or flooring, and pay on account. This is commonly referred to as a "net 30-day agreement." Don't worry, I didn't forget, you're an artist, not a contractor. Trade lines can also be a tool for building business credit. When you're trying to establish

your own business credit, search for vendors who offer Net30 Accounts — specifically ones that report to a credit bureau. A lot of my clients have used Uline, since they have a wide variety of items that you might need.

Open a business account under your EIN and make a small purchase. Be sure to pay it off before the due date. Then wait about a month and open another account, make another small purchase, and pay it off before the due date. Doing a few cycles of this will jump-start your business credit journey.

THE BETTER BUSINESS BUREAU
Banks may also pull from the Better Business Bureau (BBB). Melissa told me a story of a business owner she knew who was not able to get financing because of what was on his BBB report. When he tried to get some financing through the bank and his BBB reports were pulled, there was a collection against one of his many entities.

You see, he would open an entity, work under it, and then when things got tough, he would just open an entirely new entity and work under that one until things got tough again. The common complaint issued with the BBB was that he was not fulfilling agreements with clients that had already paid him.

What it speaks to is a pattern of behavior and a willingness to take somebody's money but then not follow through. Lenders do not want to do business with somebody like that. If they loan him money, is he going to pay it back? He hasn't honored any of his other financial commitments, so why would he honor this one?

This business owner was smart about what he was doing. It wasn't something that would be reported on his personal credit report. It wasn't even on his current EIN. Unfortunately for him, he found a lender who could figure out exactly what was amiss with a little forensic hunting. But sometimes that's part of the underwriting process.

PULL YOUR OWN REPORT
Personal credit reports are, by design, not easy to obtain. Business credit reports are different. If you know the name and location of a business, you can go to smallbusiness.experian.com and access that business's credit report in

just a few minutes. This is a great way to get your own business's credit report. You'll need to pay for that report, but just as it's important to monitor personal credit report, monitoring your business credit report is equally important.

Dun & Bradstreet provides services for monitoring your business credit score. By subscribing to their monthly plans, you can use their online platform to continuously track and manage your credit profile over time.

Equifax offers a service where you can contact them to obtain credit reports. This service is marketed for two main purposes: checking the report before engaging in business with others, and monitoring the credit of your own business.

Moreover, by responsibly using the financing option, you can progress swiftly from ERP Stage 1 to ERP Stage 3. This can aid in growing your business and turning your daydream into reality.

CLIENT VIGNETTE
Felicia's Studio

In 2018, Felicia applied for and was approved for a business credit card. She asked me what she should do with it. "Use it to pay for your cost of goods and be sure to pay it off every month," was my response.

Every time she had to pay for editing, printing, wall art, etc., she used her credit card, and faithfully every month, she would pay the balance. This started her business credit history with her bank on the right foot, which would make things easier three years later when the time came to apply for a loan. In 2021, she realized her current vehicle wasn't large enough to accommodate the wall art she was delivering to clients' homes. She called her banker: "I need to purchase a new business vehicle. What are my options?"

"You can apply for a line of credit," the banker said. "And based on your credit history with us, we can give you a loan to cover the purchase." Felicia was able to purchase the vehicle she needed.

Not long after that, Felicia received notice that she needed to move out of her studio. The owner of the space wanted to go in a different direction. She had no choice but to move. That's when she decided that she never wanted someone to have the power to do that to her again. She wanted a space that was her own, a space that no one could ever tell her she needed to leave, a space that didn't cost her $5,000 in rent every month. It was time to consult her professionals.

She called her banker. "I want to buy a studio," she said. "Do I qualify for anything?"

"Yes, you qualify for a commercial loan up to $750,000."

"OK, I'll call you back."

She called me, her bookkeeper: "Venus, I want to buy a studio. Can I afford to pay this kind of mortgage?"

I crunched some numbers and replied, "If you keep your expenses and revenue at least where they are right now, we can accommodate that payment."

"Wonderful, talk to you later."

She called her CPA: "I want a commercial loan to buy a studio space, is this a good business move?"

"Yes."

She called her business attorney: "I need an LLC so I can buy real estate."

"OK, I'll get the paperwork started."

Finally, she called the bank back. "Everyone signed off and said it's a good move for me. Let's do this."

You see how she pulled in her team of people and planned correctly to make this business move? Not that long ago, I was talking with Felicia about this transaction and reflecting on how it came about. Felicia told me, "It's not just about having that business credit, going to get an equipment loan, and getting over half a million-dollar commercial loan for my own space. I pay way less in rent than I would. And there's so much potential for that space as a business to lease it out or rent it to other people. Having a banker, a bookkeeper, a CPA, and an attorney in your corner is a game changer when you're ready to grow. I didn't expect to grow, I didn't know. But it's good having those relationships because when you're ready and you've created those relationships, they can help you get to the next step."

CHAPTER 8

Reframe. Refocus.

"When life gives you lemons, make lemonade." Normally, such peppy euphemisms make us roll our eyes, but there's more to this next version of the saying. When life gives you lemons, sometimes that can mean that life kicks you in the teeth so hard you don't think you'll ever get back up. Someone doubts or betrays you or the bottom falls out so badly that all you can feel is hurt, rage, and despair.

But you're far from hopeless. Obstacles that seem insurmountable are what keep you soldiering on. You have something called grit. It's the tenacity to get back on your feet no matter how hard you get knocked down, paired with the belief that you're standing not just because you're stubborn, but because you're stronger and more resilient than you think. Grit lets you channel the anger and pain so you can rise like a phoenix and clap back hard at the doubters.

And that, my friends, is Felicia Reed. "I didn't set out with a big audacious plan to be the next Annie Leibovitz. I was a mom with a camera. That's how it all started." Simple. Direct. Honest. That's how Felicia rolls. She gets right to the point.

She was a 40-year-old woman and mother looking to take better photos of her children. She wanted something new for her life. She was only interested in photographing women, mothers specifically, and that came from the simple fact that she was one. That commonality of experience is at the heart of what she does as an artist.

As a result of her passion, Felicia Reed Photography had a humble start in 2014, a full three years before she entered my life, bringing with her an indomitable spirit and messy bookkeeping.

I first introduced you to Felicia in Chapter 1 — how she was killing herself working at a full-time sonography job while also doing photography nights

Chapter 8: Reframe. Refocus. **91**

> *"Courage does not always roar. Sometimes courage is the quiet voice at the end of the day saying, 'I will try again tomorrow.'"*
>
> —Mary Anne Radmacher

and weekends for a mere $75 per session. Now, at age 50, Felicia's reimagined life includes a nearly seven-figure career, a stand-alone studio, speaking engagements, and an online coaching academy. "Taking better photos of her kids" has evolved into a portfolio of gorgeously crafted, choreographed images that blur the lines between portraiture and self-empowerment.

The thread that has emerged is the determination and resilience of every single one of the women she photographs, and it shows up every day in their dreams. These women went for it. At their most vulnerable, they trusted Felicia and challenged themselves. But first, Felicia had to challenge herself.

REFRAME. REFOCUS.

Finding Meaning at 40

"So, what do you do?" That was always one question that would send Felicia's stomach into knots and her heart rate through the roof. She would hesitate as the familiar feeling of emptiness would wash over her. Obviously, she

knew what she did—she'd been an ultrasound tech in the medical field for 15 years. But it was just a job. It was good job, and it was fun in the beginning, but nothing in the role gave her any sense of purpose, direction, or fulfillment.

She was also a mom of small kids at the time, and she was taking all kinds of classes—cake decorating, sewing, and photography classes—all in an effort to find herself. Or rather, to discover her passion. "Ultrasound just didn't light my fire; it bored me. And if you find something boring, it's pretty damn hard to make it sound exciting." The big 4-0 was looming on the horizon. I know, it's cliche. But looking back, it's easy to see that as that milestone inched closer, she began to feel like she had lost her way. Even though she had a healthy family, had a good career, and had achieved some of the goals she set for herself, she just started to question whether she was on the right path.

REFRAME. REFOCUS.

At first, it was about her and her experience—quitting her job at the age of 40 and starting all over. She was transitioning her life. Felicia's life wasn't over, it was just beginning. Although culture doesn't tell us that; culture says women over 40 are old. The truth is that women over 40 deserve to be celebrated. We're too experienced to not be heard and too beautiful not to be celebrated. Felicia embarked on a mission to reframe and refocus the global perception of aging, aiming to empower mothers and women, particularly those who may have lost their sense of self, to recognize their own strength and beauty.

"Photography was the first thing that sparked my creativity in years, and part of that was definitely due to being a mom. My second child was born in 2004, and I wanted to photograph his journey of growing up. I missed out on those years with my oldest because I was in school and trying to build my career."

Now that Felicia was a little older and wiser, this was her chance to do it differently. So, she picked up her camera, seeking to create something unique, far from the typical photographs. She styled her portraits in black and white and documentary style. It didn't take her long to notice there was a void in the way we celebrated and focused on our families and children, and yet as moms, we rarely took photos of ourselves. We hid behind

the camera. Maybe because we didn't like the way we looked or didn't think we were worthy to exist in photos for some reason. Felicia, on the other hand, wanted badly for someone to take a great photo of her, but it rarely happened. There's a difference between a "nice" photo and a portrait that captures your soul and the essence of a person.

So that's when Felicia Reed Photography was born, in 2014.

The Valley of Self-Doubt

If you're launching a business, you have probably heard the horror stories of business failure after business failure. Listen to some of the naysayers and you'll start believing that 90% of new businesses are destined to fail. However, the reality is much brighter: According to the U.S. Bureau of Labor, 75% of new businesses survive the first year, 69% survive the first two years, and 50% make it to five years. Granted, a 50-50 chance of surviving to year five may not sound that great, but you don't have to sit back and let chance dictate your fate. And that's definitely not in Felicia's DNA.

Truthfully, the beginning was rough for her. I'm not going to lie. It's not like you come out of the gate, and all these people are lined up to hire you. In the years before she went full-time, she was photographing families and children on the weekends for less than $100. And even when she finally quit her day job and launched Felicia Reed Photography, she still struggled. Weeks would go by without any clients. By nature, Felicia is a very, very positive person with high energy, but by the third year, she was just feeling overwhelmed. "What have I done? When is this going to work?"

By the time I met Felicia in 2017, she was at a breaking point. Her "spark" was dimming and the constant struggle of trying to grow a business had blurred her vision of why she started taking photographs in the first place. Knowing she needed to reframe and refocus, she hired me in October 2017. It was a huge stretch for her and wasn't easy to ask for help. Her books were messy, but she saw them as a train wreck. She had no idea how to make a profit, let alone grow her business. She trusted the process immediately, and she knew it was the right move, but by April 2018, the well was just dry. What

seemed initially like a setback actually turned out to be an amazing thing for Felicia and her business. It compelled her to reframe and refocus once more.

It was a Tuesday when I got the call that she thought she needed to cancel my bookkeeping services. She was terrified about the diminishing funds in her bank account and didn't think she could still cover the monthly investment. I calmly told her she needed to give me 30 days' notice. She was hesitant, but agreed, not thinking it would even make a difference. This period marked a highly stressful phase in Felicia's life and the life of her business. Hiring a bookkeeper had its own challenges, since it involved exposing the raw, vulnerable aspects of the business — they see all the numbers and understand every detail. Felicia felt incredibly low.' Despite liking, even loving my work, and publicly acknowledging my good job, she was plagued by financial worries. She couldn't see a way to afford my services, let alone her other expenses. Through her lens, it appeared as though her photography business was on the brink of failure.

REFRAME. REFOCUS.

I sensed something extraordinary within her, and deep down, she knew it too, yet she couldn't recognize it. That's when I suggested, "Let's view this through a different lens." Together, we developed a sales promotion. I asked for her commitment to give it one last effort, promising that if it didn't succeed, I would terminate our contract.

Remarkably, something within her transformed. Her energy shifted, reigniting her excitement. The result was astounding: She booked 28 sessions and ultimately chose not to cancel our contract.

Love, Money, Mindset.

The next year went gangbusters for Felicia's business. That sales promotion turned into another, and another, and another. Money was flowing. That's when she started implementing Profit First. But, for Felicia, things shifted again when 2019 brought another blow to her. Even though her

Chapter 8: Reframe. Refocus. 95

business had been booming, clients were starting to cancel. After 26 years of marriage, she was not getting along with her husband and felt as if she couldn't stand him anymore. Her energy and spark were off kilter, and she felt as if everything in her life was a struggle. I'm telling you ... life will really test you sometimes.

Realizing she needed to reframe and refocus, Felicia confided in her life and love coach who helped her realize that her struggles weren't about her husband. They were about her. "Right now, you're like the sun, you're burning anyone who comes close to you. Your husband, your clients, your friends." When Felicia heard those words, something inside her clicked, and she realized she needed to work on her mindset management. She needed to work on her. So that's exactly what she did.

REFRAME. REFOCUS.

She started working with a love coach. She went all in on working on her own happiness. Once she figured that out, it was like magic, and she started manifesting the ideal clients, manifesting the opportunities, and manifesting the revenue. I remember the day I asked Felicia what she was doing differently. Where was this revenue coming from? That was when she explained what she had learned, and I heard the excitement in her again. I could actually see the spark!

As Felicia worked on herself, business got better. Every month was better than the last. In six months' time, she had turned things around from a business that had constant cancelations to a business that was totally booked seven months in advance. She went from a wife who thought she couldn't stand her husband to a wife reconnected with her husband and having a phenomenal marriage again. She had to reframe and refocus to learn that energy transfers, it doesn't discriminate, it doesn't care. Just because you have something going on at home doesn't mean it's not going to affect all parts of your life. You have to have that harmony in your life.

Anytime her bank account gets low these days, I always remind her to get back to herself first. Go back to the mindset and manifesting. That simple

request will reset her to reframe and refocus. Learning this about herself in 2019 couldn't have happened at a better time.

In 2020, when the whole world was affected by the pandemic, Felicia was in the best place in her life mentally and emotionally. The business was doing well. Profit First was in place, so her salary was paid, and her accounting records were in order, so she was able to qualify for the available assistance from the government. By the time 2021 came around, Felicia had just completed her best year in business, doubling her salary from the year before. She had completed her first 40-over-40 campaign, which has become her signature event. She was leveraging the power of Profit First to purchase her own stand-alone studio space.

In Sickness and in Health

Remember what we said about life handing you lemons? In November 2021, during a routine mammogram, Felicia received an unexpected callback for additional images, and then a biopsy. On December 7, that fateful call came: "You have cancer." The ground seemed to crumble beneath her, and all she could think was ... Not again.

Breast cancer has affected her entire life. She was 18 when her mom died at age 40 from breast cancer. Her younger sisters were diagnosed with breast cancer in their 30s. One is currently in remission, and the youngest, like her mom, lost her battle to metastatic breast cancer. Even her ultrasound career was mostly focused around breast sonography in the breast imaging department at the hospital. Back then, she was resolute in her determination to empower every patient she worked with. Her aim was to ensure that, regardless of their diagnosis, they understood they were not defined by what was happening or had happened to them, even when confronting the most daunting news.

Now, she faced the challenge of applying that same empowerment to herself. And believe me, it was extremely difficult. Fortunately, her dedication to mindset work with her life and love coach, coupled with her financial health, bolstered by the 'Profit First' approach, enabled her to move past

anger and fear and into a mode of action. She was presented with the option of undergoing 12 weeks of chemotherapy, and the choice of a mastectomy to potentially avoid radiation. She chose to proceed with that plan.

REFRAME. REFOCUS.

On Jan. 4, 2022, she started the new year with her first chemotherapy treatment. She went every week through March, and on the first Tuesday in May, she had her mastectomy and reconstruction. During that time, she never stopped working. Sure, she took time off for treatments, but she still managed to work at least three days a week up until her mastectomy. Then she took four months off to heal. But during that time, she never stressed about money. Not even once. Why? Because she had the business and bookkeeping tools in place. She was a few years into implementing Profit First and had her profit distributions to help her if it was needed, freeing her up to reframe and refocus solely on herself.

Being a deeply spiritual person with an incredible relationship with God, she had to rely heavily on His promises. It was essential for her to focus on something positive and inspiring to look forward to, like building the new studio. This forward-looking perspective helped sustain her through the challenges. She used this time to work on herself. Eating healthier and exercising helped her through chemo. Cutting back on her hours working helped her rest, but she is not a person who can just lie around. This is when she launched her coaching business. She knew she had to have a life with purpose, and her purpose is to serve these incredible women that God puts in her life and in front of her camera.

"Isn't that a beautiful thing? I'm still so blessed by it all," is what she says when she thinks of that time.

"Even when faced with cancer and what turned out to be four different surgeries, I was able to choose. I made the decision that I'm going to choose health, I'm going to choose happiness, I'm going to choose joy. I'm going to choose to succeed through this whole thing, that I can run a business and I can have cancer at the same time. I can run a profitable business. And I did."

When looking at the 2022 numbers, she worked fewer hours, made more time for her health and family, and still made about $356,000. She opened a studio with the money she leveraged from Profit First. She created an online coaching academy. Cancer sucked, but it was such a blessing, too. It caused her to find balance and harmony in her life and business. She spent time cooking in the kitchen, dancing in the living room, and having fun with her family.

When hard times come or adversity hits, it doesn't last long and there's always something even greater on the other side. We all have lived long enough to know this. But when things don't seem to be going the way you thought they would go, keep reminding yourself that there's always hope for a better tomorrow.

REFRAME. REFOCUS.

> *"Be an example to others that, no matter what life throws at you, you have a choice. And I choose joy and happiness every day."*
>
> —Felicia Reed

ABOUT THE AUTHOR: VENUS MICHAEL

Venus Michael, founder of One21 Account-Ability, is a transformative figure who turned a career setback into an opportunity for empowerment. With a focus on combating entrepreneurial poverty, her partnership with Mike Michalowicz has catalyzed a movement towards financial mastery within the photography community. Her book, *Profit First for Photographers*, and related services provide photographers with practical tools to transform their passion into profitable businesses.

A speaker and author, Venus infuses personal experience into every engagement, offering insights that are both practical and transformative. Her approach is deeply personal, making complex financial concepts accessible and actionable. This has established her as a trusted mentor in the photography industry, guiding many through their transitions from hobbyists to successful business owners.

Venus's influence is reflected in the success stories of those she has helped. By implementing the Profit First methodology, she has not only reshaped her own destiny but has also paved the way for photographers to achieve financial stability and creative fulfillment. Her work is a testament to the power of resilience and strategic financial planning in building thriving businesses.

ONE21ACCOUNTABILITY.COM
VENUSMICHAEL.COM

APPENDIX A

Opening a Business Bank Account

When going to open a business account, you will need your entity formation paperwork. That can include your assumed name certificate that is filed with the county or state you operate in and the EIN letter from the IRS. It's not difficult to open a business bank account, but it's recommended that you do it in person and not online. When doing it online, you don't know what you don't know. You might incorrectly enter your information, causing a huge headache down the road when you call customer service or go into a branch because you need help.

Banks try to make it easy for people, but people do fill things out incorrectly, especially on business accounts versus personal ones. So, the best bet is to take your EIN letter, your certificate of formation, your driver's license, and yourself, along with any signers you want on your account, and walk into a branch.

The nice thing about doing that in person is if you add additional products online, all the compliance stuff that banks must follow is all set up correctly because a banker set up your profile for you instead of just an online platform system. "When I look at my financial statements, it's like the numbers are jumping off the page and dancing. It just doesn't make sense to me." (Yes, someone told me that one day during a discovery call. She is very sharp and smart, but when it comes to accounting, it can be difficult to understand.)

Profit First Friendly Banks. The following national and regional banks are considered to be very compatible with the Profit First system. Level of compatibility may vary by branch. Credit Unions are typically more friendly due to flexibility. If you want to open an account at any of these banks,

remember that communication is key! Let them know you're interested in a Profit First approach, and they may be able to better serve you.

- 1st Internet Bank
- 5th 3rd Bank
- Adirondack Trust
- Advia Credit Union
- Affinity Credit Union
- Alliant CU
- American Bank
- Bank of America
- Bank of Iberia
- Bank Iowa
- Bank of the Ozarks
- Banner Bank
- BBVA Compass Bank
- Carver Bank
- Centennial Bank
- Citizens Union Bank
- Community Bank of Colorado
- Commercial Bank of California
- Coastal Federal Credit Union
- DL Evans Bank
- Empower Federal Credit
- Enterprise Bank & Trust
- Fairwinds Credit Union
- Fidelity
- First Citizens Bank
- First Fidelity Bank
- First Financial Bank
- First National Bank of NWA
- First American Bank
- First State Community Bank
- Franklin Synergy Bank
- GlensFalls National Bank
- Greenwoods State Bank
- Goldman Sachs
- Heritage Bank of Nevada
- Idaho Central Credit Union
- Intrust Bank
- Key Bank
- Landmark Bank
- Leaders Bank
- Legacy Bank
- Live Oak Bank
- M&T Bank
- Middlesex Savings
- Neighborhood Federal Trust
- Needham Bank
- Novo Pathfinder Bank
- Parkway Bank & Trust
- Point Breeze Credit Union
- Peninsula CU
- Regions Bank
- Northwest Bank
- Pinnacle Financial Partners
- Point Breeze Credit Union
- PNC
- Providence Bank
- RCB Bank
- Regions Bank
- Relay
- Rogue Credit Union
- Saratoga Springs
- Scott Valley Bank
- Signature Bank
- Spring Bank
- Summit Credit Union
- SunTrust Bank
- Tri Counties Bank
- US Eagle FCU
- US Bank
- Umpqua Bank
- US Bank Silver Checking
- Unify CU
- Union Bank of California
- Vystar Credit Union
- Wood Forest Bank

APPENDIX B

Additional Bank Accounts

At Profit First headquarters, they have a saying: "When in doubt, create an account." If you ever say, "I'd like to have money set aside for _____," that's your cue to possibly open an account. That being said, I do not recommend just opening accounts for the sake of opening accounts. Every account needs to have a purpose. Here are some of the popular ones.

PREPAYMENT ACCOUNT

A common mistake I see with business owners who offer a prepayment option is that they will treat those funds for services not yet rendered as income. You must remember that, until you earn that money, it's not yours. If the client requests a refund — even if you have a policy of no refunds — you suddenly have less money than you accounted for, and you now run the cash flow risk of being unable to pay for the costs of the job. The best strategy is to set those funds apart until the sale is final.

PAYROLL ACCOUNT

One of the most stressful things business owners can go through is figuring out how to write paychecks in a cash flow crunch. If you have employees, you have to pay them the full amount due at the time due, or you can get in a lot of legal trouble. Having funds set aside in a payroll account can bring peace of mind in knowing that when payday rolls around, you're prepared to take care of your people.

VAULT ACCOUNT

Commonly referred to as the "rainy day fund," a vault can be a powerful thing when the going gets tough. Many of my clients who are implementing some advanced techniques will use the vault account as a self-funded line of credit.

CHARITY ACCOUNT

Whether it's a major nonprofit like the Red Cross, your local church, a scout troop, or anything else you think of as charitable (tax write-off or not), it's getting more popular to a small percentage away for the purpose of giving back.

GALA ACCOUNT

Studio portrait photographers, I'm talking to you. A very popular campaign to do is the "40 over 40." These are typically larger sales and can be very successful in injecting cash into your business. Once the campaign is completed, there's usually a black-tie gala to celebrate everyone's photos and showcase your work. The average price for a gala like this is $5,000 to $7,000. So, we set that money aside (a little bit every sale) to cover the overhead cost.

APPENDIX C
Business Essentials Accounting Glossary

Here are the definitions you need to know as a CEO. Stick with me, I understand this is boring. I'm not going to give you the entire dictionary but the highlights of what you must know.

ACCOUNTING
Accounting is the process of recording, measuring, interpreting, and communicating financial data. It includes disciplines such as auditing, taxation, financial statement analysis, and managerial accounting. Accounting goes beyond record keeping functions of a bookkeeper.

ACCOUNT
Specific balance sheet or income statement item. A separate account exists for each asset, liability, equity, revenue, and expense.

ACCOUNTING SYSTEM
Methods, procedures, and standards followed in accumulating, classifying, recording, and reporting business events and transactions. The accounting system includes formal records and source data. Regulatory requirements may exist on how a particular accounting system is to be maintained.

ACCOUNTS PAYABLE
A short-term liability account. Usually due in 30 days or less. The liability is not set up as a loan, and interest is usually not charged unless the business is late on its payments. An example is purchases or inventory items on an account from a supplier.

ACCOUNTS RECEIVABLE
Income from sales or services that have not yet been received, usually due in 30 days or less. The asset is not set up as a loan, and interest is usually not charged unless the account is past due. For example, billing customers monthly for services performed during the month.

ASSET
An economic resource that is expected to provide benefits to the business. Assets include cash, inventory, accounts receivable, equipment, buildings, land, goodwill, trademarks, prepaid expenses, etc. An asset has three characteristics:
1. Future probable economic benefit
2. Control by the business entity
3. Results from a prior event or transaction

BALANCE SHEET
A financial statement that illustrates the financial position of a business at a specified point in time: what it owns, what it owes, and the owner(s) share. The balance sheet typically has three sections: assets, liabilities, and equity. Assets are organized by ease of liquidity, liabilities are organized by a term of debt repayment, and equity is organized based on the type of legal entity. Line items within each section represent the balances or the general ledger accounts. Individually or grouped by related types.

COST OF GOODS SOLD (COGS)
The price of buying or making an item that is sold. The difference between sales and COGS is the gross profit.

EXPENSES
Outflows or other use of assets or occurrences of liabilities as a result of producing or delivering goods, rendering services, or carrying out other operations of the entity.

FINANCIAL STATEMENT

A report containing financial information about an organization. The required financial statements are balance sheet, income statement, and statement of change in financial position.

FIXED COST

An expense that remains constant in total regardless of changes in activity within a relevant range.

GENERAL LEDGER

The record of a business entity's accounts. The general ledger contains the accounts that accumulate all the entity's transactions and accounting adjustments. This raw data is translated into meaningful information when presented in the form of financial statements. Separate accounts exist for individual assets, liabilities, equities, revenues, and expenses. A trial balance is prepared from the general ledger account at the end of the accounting period to assure that total debits equal total credits.

INCOME STATEMENT

A financial statement that illustrates the activity and profit or loss status of a business for a specified period. The report illustrates revenues from all sources, by categories of expenses, listed in total; the various operating expenses, or categories of expenses, listed separately and in total; and finally, the net income, or net loss. The results of the period's activity will increase or decrease the owner's equity.

OPERATING EXPENSES

Expenses not associated with COGS, such as the selling and administrative activities of the company. They represent costs related to time rather than to the product that is sold.

REVENUE

Actual or expected cash inflows that have occurred or will eventuate as a result of an entity's major or central operations. Revenues include sales, royalty income, and rent income if part of the entity's core operations.

APPENDIX D

Profit First Commitment Card

USE THIS SECTION TO LOG YOUR PROFIT FIRST GOALS, SCHEDULE, AND COMMITMENTS.

My Profit First Journey began on _____
<div align="center">date</div>

Allocation Rhythm. I will make my allocations on these days:

☐ *Weekly* on _____
<div align="center">day of the week</div>

☐ *Every other week* on _____
<div align="center">day of the week</div>

☐ *Semi-monthly* on the _____ and _____ of each month
<div align="center">1st-30th 1st-30th</div>

I will make my first allocation on _____
<div align="center">date</div>

My S.M.A.R.T. Business Goal

Specific: _____

Measurable: _____

Attainable: _____

Relevant: _____

Time-bound: _____

APPENDIX E

Fillable Instant Assessment

	CURRENT $	CAPS	TAPS	PF $	THE BLEED	THE FIX
REAL REV.						
OWN. PAY						
TAX						
GROWTH						
EQUIP.						
OpEx						
PROFIT						

Fill out the chart above with your real data following these steps:

- **Real Revenue:** Fill out the equation below. Write the result in this cell.

$\$\underline{\hspace{3cm}} - \$\underline{\hspace{3cm}} = \$\underline{\hspace{3cm}}$
 Top Line Revenue Cost of Goods Sold Real Revenue

- **Current($):** Enter your allocations from the last 12 months.
- **CAPs:** Divide Current($) by Real Revenue and multiply by 100.
- **TAPs:** From the table on page 48, find the column that best matches your Real Revenue. Copy the percentages from the table.
- **Profit First $:** Multiply Real Revenue by TAPs and divide by 100.
- **The Bleed:** Subtract Profit First($) from Current($).
- **The Fix:** If the number in Bleed is negative, write "increase." If it's positive, write "decrease."

Download as a printable PDF (or a fill-in-the-blank Excel file) at profitfirstforphotographers.com.

APPENDIX F

Profit First Workbook Sample Sheets

Along with the other tools available at profitfirstforphotographers.com, you will find Venus Michael's Profit First DIY workbook, which contains three years' worth of assessment charts, budget trackers, and thought-provoking "Zoom In" segments designed to keep your business running more and more efficiently quarter after quarter.

The following pages contain samples of these worksheet pages, so you can try them out and see if you like them before implementing them into your business.

GOT QUESTIONS?
For personalized feedback and expert advice, contact profit@venusmichael.com.

Quarterly Snapshot

Q _____ of _____
#1-4 year

	Before		After		
	Old CAPs	TAPs	Bank Balance ($)	New CAPs	% Change
Profit					
Owner Pay					
Tax					
Equipment					
Growth					
OpEx					

Reflect
What were your goals for the quarter? Did you meet them? What worked and what didn't?

My Profit Distribution: $_____

How will you use your profit? *(Remember: this should be spent on you — not on your business)*

QUARTERLY PROFIT FIRST SNAPSHOT
Download the complete workbook at profitfirstforphotographers.com

Zoom In #1: Expense Analysis

A common misconception about the Profit First approach is that it focuses exclusively on reducing expenses. In reality, there are plenty of additional opportunities we'll look into to improve the profitability of your business. During each Progress Photo, we'll focus on a new Profit Point and equip you with new tools to help you meet each goal more effectively.

When was the last comprehensive, in-depth analysis of the expenses on your Profit and Loss statement?

What system do you have in place to track your expenses and verify your ROI? Are you happy with it?

What costs do you think you could reasonably cut without harming your business? _____

(Remember: this is an exercise, not a commitment.)

By what % could these cuts reduce your expenses? _____

> *"When life seems hard, the courageous do not lie down and accept defeat; instead, they are all the more determined to struggle for a better future."*
>
> —Queen Elizabeth II

ZOOM IN: A NEW ASPECT OF YOUR BUSINESS EVERY QUARTER
Download the complete workbook at profitfirstforphotographers.com

Zoom Out: Goals for Next Quarter

What I want to achieve: _____

What changes I will make to get there: _____

Allocation Goals

	CAPs	TAPs	+/-
Profit			
Owner Pay			
Tax			
Equipment			
Growth			
OpEx			

Notes

ZOOM OUT: GOAL SETTING FOR THE NEXT QUARTER
Download the complete workbook at profitfirstforphotographers.com

Budget for _____
month

$ _____
income account balance

Allocations

Account Name	%	$
Profit		
Owner's Pay		
Equipment		
Business Growth		
Operating Expenses		

Bills Due: **Fixed Expenses**

Date	Description	$

TOTAL: $ _____

Bills Due: **Variable Expenses**

Date	Description	$

TOTAL: $ _____

Wins & Opportunities

Recap: Creating a Stash of Cash

	Goal	Actual	Difference
Earned			
Spent			
Debt			
Saved			

MONTHLY OR QUARTERLY BUDGET TEMPLATE
Download the complete workbook at profitfirstforphotographers.com

Made in United States
Orlando, FL
09 July 2024